NANCY BROWN
with MICHAEL O'CONNOR

PHOTOGRAPHING PEOPLE FOR
ADVERTISING

AMPHOTO
An Imprint of Watson-Guptill Publications / New York

Editorial concept by Marisa Bulzone
Edited by Robin Simmen
Designed by Areta Buk
Graphic production by Ellen Greene

Nancy Brown worked as a top model in New York City for nineteen years. Nine years ago, she and her husband, David, opened what has become one of the most successful photography studios in New York. Nancy Brown specializes in advertising photography for such clients as Maidenform, Coty, Merle Norman, Canada Dry, Pentax, and Avon, and has done extensive editorial assignments for such magazines as *Glamour*, *Working Mother*, *Redbook*, *Cosmopolitan*, *McCalls*, and *Woman's Day*. In addition, Ms. Brown gives many seminars and workshops across the country and thoroughly enjoys teaching. She is a board member of the Advertising Photographers of America and is a member of the American Society of Magazine Publishers.

"During all the years I was modeling, photography was my big interest so becoming a photographer was a natural move. I love taking pictures of people and feel very fortunate that I can combine what I really love with how I make a living."

Michael O'Connor is a writer, photographer, and editor based in New York City and specializing in the subjects of travel, architecture, photography, graphic design, and printing technology. He has written for numerous publications, including *The Photo District News*, *American Photographer*, *Print*, *How*, *Art & Antiques*, *The Guilfoyle Report*, *Photo/Design*, and *ZOOM*.

First published 1986 in New York by AMPHOTO, an imprint of Watson-Guptill Publications, a division of Billboard Publications, Inc., 1515 Broadway, New York, NY 10036

Library of Congress Cataloging in Publication Data

Brown, Nancy (Nancy Walker)
 Photographing people for advertising.

 Includes index.
 1. Photography—Portraits. 2. Photography, Advertising. I. Title.
TR575.B77 1986 778.9′2 86-14012
ISBN 0-8174-5438-1
ISBN 0-8174-5439-X (pbk.)

Manufactured in Japan

2 3 4 5 6 7 8 9/ 91 90 89 88

For David, Kendra, and Jordana

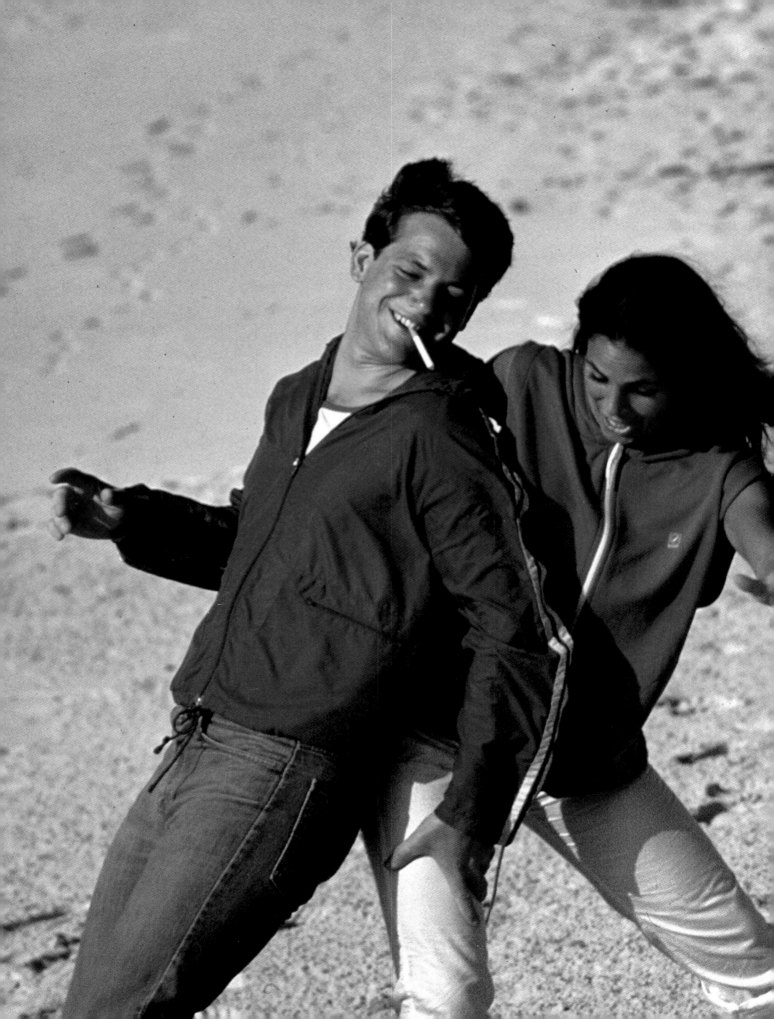

INTRODUCTION

This book is specifically about commercial photographs of people for use in advertising. It is about one person's way of taking pictures—my way—because that is what works for me. It is not a book about all types of photography, or the many other ways you can take pictures.

This book contains information, and thoughts, about what I consider to be my most successful pictures. I hope it includes information of value to you—the reader and the photographer—with seeds of ideas, advice, and techniques you can use in your own pictures.

The business of professional photography is not easy, no matter how good your pictures are. Jobs are scarce. Good clients are hard to find. The costs and risks of running a commercial studio are very high. There is a great deal of good competition for every paying photography assignment.

However, you can break into the business of professional advertising photography. I did. If you're good, willing to work hard and sacrifice to get started, have a lot of patience, and you understand why certain kinds of photographs sell to certain people—and if you get a few lucky breaks—you can become a successful photographer. If you're a good businessperson and intelligent manager, you can remain a successful photographer and build a good career.

I have always loved photography. I decided to become a professional eight years ago, after being a professional model for 20 years. I began by taking pictures for a portfolio, and took photographs of the people around me—my family, friends, and neighbors. I walked up to people in restaurants and asked to take their pictures. Gradually, I built up a portfolio, began to show the pictures and got paying clients.

From the beginning, I knew exactly what type of pictures I wanted to take—pictures of people. I have always liked photographing people more than objects, buildings, landscapes, or anything else. I enjoy being with friends, meeting new people, and working together with them as a team. Thus, it was only natural for me to concentrate on photographing people. I don't believe in doing things you don't really like. Life is just too short.

I also knew I wanted to concentrate on photographing people for advertising. I have always thought with a commercial frame of mind and find it an interesting challenge to make photographs for use in advertising and commercial jobs. Even when I photograph my family or friends, I look at the situation with a commercial eye. Commercial photographs are the type of pictures I do best and the kind I most enjoy taking.

After I began getting jobs as a photographer, I rented a small studio and started learning about strobes and studio lighting. I soon moved into a larger studio in the heart of New York's commercial photography district, out of which I've been working for about seven years now.

When I take pictures, I hardly ever work alone, but usually

with a team of talented professionals—models, art directors, assistants, stylists, hair and makeup artists, set builders, backdrop painters, location scouts, and many others. The pictures I take do not always involve that many people. Some involve only two: a model and myself. However, almost every picture in this book has required influences, input, or simple logistical legwork from other people besides myself.

If someone asked me to summarize the secret of successfully taking pictures of people, I would say that the most important thing is catching the right moment. By that, I mean the instant when something good is happening—an expression, a movement or feeling. Sometimes the situation is right from the minute you start shooting; at other times, you have to wait for the session to build before the moment is right and the pictures begin to turn out properly.

There are some fundamental ways I operate and approach a shooting, no matter how complicated or simple a photograph appears to be:

... I always plan the shooting in advance—every detail. I determine what I want to accomplish, and how I am going to do so. I make sure everything is ready, and always have more props, clothes, and accessories on hand than are really needed. You never know what will happen, or what will click.

... I work together with the other people who are on the shooting. I talk about the photographs with my team,

listen to their ideas, and ask for input and advice. I make the final decisions, but I listen to everyone else.

... I work to make sure things run smoothly, and try to make everyone as comfortable and content as possible—especially the models. If people are hungry, I don't keep pushing, but break to eat. If someone thinks the music is too loud, I turn it down.

... I try not to overdirect models, or order them around. I talk to, and encourage, them and see what happens. Often, I just go with the flow of the talent.

... I shoot a lot of film, and don't worry about how many rolls I use. I want the right picture. Sometimes I get the photograph right away, and other times it takes awhile (and a good deal of film) before the models are in the right mood and the pictures have the right feeling.

... Finally—and perhaps most importantly—I have a very positive attitude while I shoot. I try to be as optimistic, "up," and energetic as possible. It may be part of my personality, my particular approach to life, but you'd be amazed at how it catches on. A positive approach influences other people, makes them feel better, and causes them to try just a little harder. Even when we work very hard, I believe people have fun and enjoy it, and thus produce more creatively. That extra energy and effort can make all the difference in your pictures—and *your* pictures are what this book is really about.

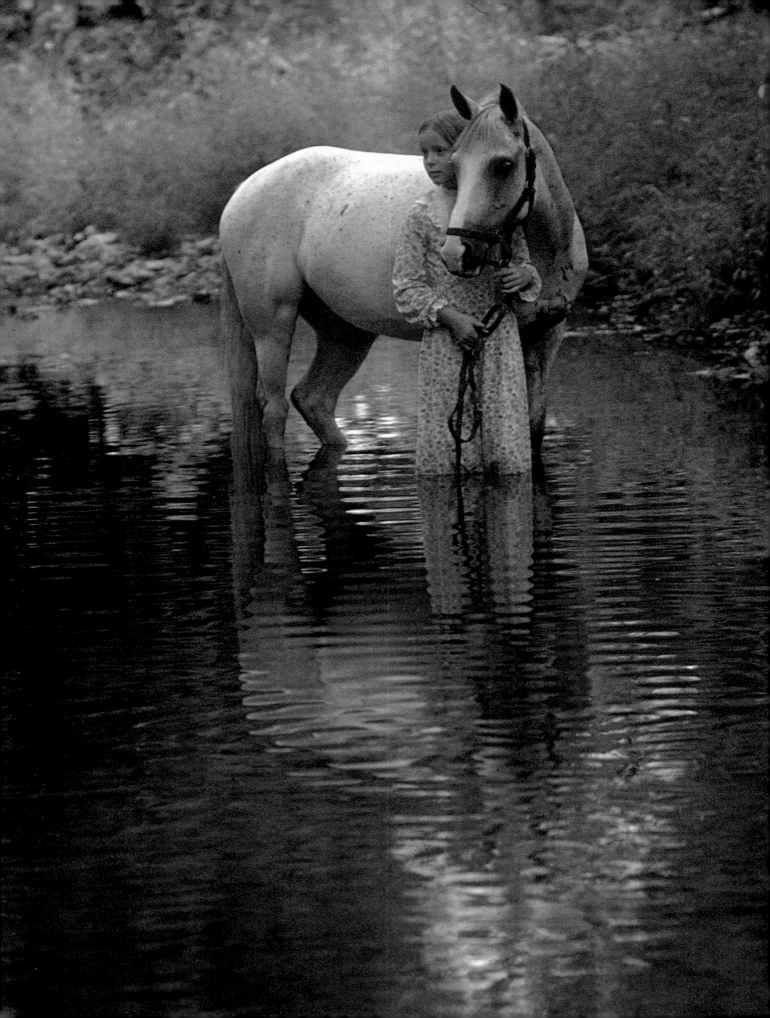

Chapter 1

PHOTOGRAPHING FRIENDS AND NEIGHBORS

You don't necessarily have to work with professional models when building a professional advertising photography portfolio. "Real" people have real strengths and personalities. The people with whom you come into contact every day—your friends and neighbors, doctors, plumbers, writers, secretaries, and housewives—can have incredible looks and be terrific subjects for your camera.

Professional models may be more experienced and comfortable in front of the camera than amateur friends and neighbors, or have a certain type of look, but real people can provide the raw material for powerful photographs. All it takes from the photographer is a little practice and skill.

What matters more than the model you choose to work with is the type of photographs you make—the way you make a person look, the type of situation you set up, and the ideas your photographs convey to the viewer.

What matters most when developing a portfolio and breaking into the business is that your photographs are the type that work for the stylized world of advertising. If you study the pictures in magazines, catalogs, and newspapers, you will see a great difference between an advertising image and an informal snapshot.

An advertising photograph is usually a very structured, set-up image, even when designed to convey a feeling of spontaneity or casualness. Most often, an advertising photograph is *made*, not taken. There is an enormous difference. A friend of mine, David Langley, a top advertising photographer, likes to say, "I am a *picture maker*, not a *picture taker*."

Many of my pictures seem quite simple, and don't require complicated technique or unusual equipment, but they are all very structured. Almost all contain an obvious idea, or make some particular statement.

When I started out as a photographer and put my first portfolio together, I worked almost entirely with friends and neighbors as models. To this day, I still enjoy working with amateur models and people I meet in the course of daily life.

When I first got started, sometimes I would see someone in a restaurant who might look good in a particular type of picture. I would go over and say something like "I am a photographer—blah, blah—and I'd like to take pictures of you." Usually, the person felt complimented and said yes.

Right away, I had a business card made, and I'd give it to people and ask them to call me on a particular day. Sometimes if they were especially hesitant about posing, I'd offer to take a picture they could use. I'd say, "If you do a session for me, I'll do a portrait of your family for a Christmas card." I'm always very positive when I approach someone.

Maybe the fact that I'm a woman has made it easier to approach strangers. People might feel more intimidated when approached by a man—but probably the most important factor is that I'm always very positive. "It'll be fun," I'll say, "and maybe we can have lunch or dinner afterwards, and enjoy ourselves." Indeed, we almost always enjoy ourselves.

The first few times I approached total strangers, I felt awkward. But after I had done it a few times and the pictures worked, I never had the problem again. After you take pictures that people like, and give them slides or prints, they are usually eager for you to photograph them again. The pictures you take of "real" people can be very powerful.

This is the same model who is in the picture with her brother in profile on page 13. I also have photographed the stream a number of times. I use the same people, the same models, over again. Once you have developed rapport and a relationship with a model—they know how you work, like the pictures you take, and you know what they are capable of—the pictures tend to get better.

For the same reasons, I often go back to the same locations. I learn about them—what time of day the light comes from what direction, when it hits a magnificent old tree or sets behind a certain hill—and that helps to make future pictures even better.

SETTING UP A STRUCTURED PICTURE

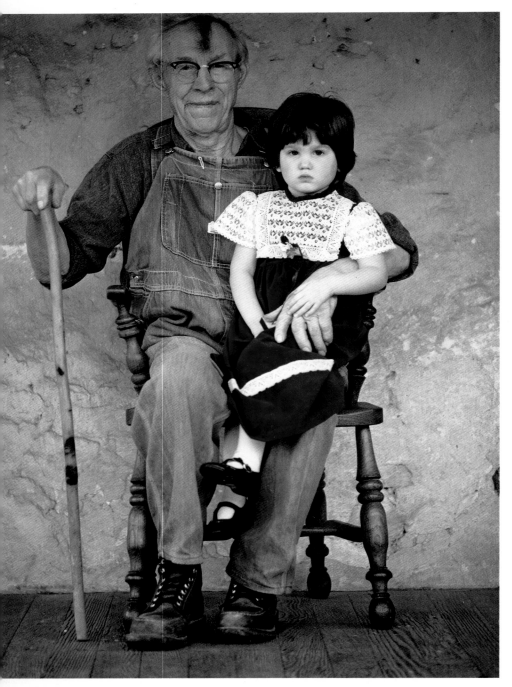

This picture was taken in Bucks County, Pennsylvania, where David and I once had a country home. It is one of the first photographs I took after deciding to build an advertising portfolio.

When I was in the country, I jogged. Every weekend I ran by this particular house and the old man was always on the front porch. I loved the way he looked sitting there, so one day I ran up to the house and started talking to him. His name was Mr. Sieffert.

I had this idea of shooting an image that contrasted youth to old age—showing both a big and little hand. It seemed to be the kind of picture you could use to advertise a number of different products. Mr. Sieffert looked perfect for that, so I asked him to pose with the daughter of a neighbor of mine, Pam. He was more than happy to do so. Even though Mr. Sieffert and Pam didn't know each other, they became friends.

The props—the clothes and cane—came from an antique store. The chair is from my house. Mr. Sieffert wore the overalls I had seen him in every day. Pam put on the dress—she loved having a new dress on—and sat in Mr. Sieffert's lap. I gave them a bit of direction, but they posed themselves. Pam didn't need to be told to put her hand on top of his, but did it automatically. That contact provided the real key to the whole image.

We shot for half an hour, certainly not longer. People who aren't experienced models get impatient after about half an hour. You see it happen as you work—the enthusiasm and energy start to slip—and you certainly see it in your photographs.

All of the pictures were taken under available light in the shade on the front porch. There was no need for additional reflectors or lighting. The light was great there at that time of day.

The camera was a Nikon, and I used a 105mm lens without any filters. That was before I discovered the No. 1 diffuser. Using a slightly long lens flattened the perspective somewhat, and produced a "pictorial" feeling. As with most of my photographs (except the very grainy ones), it was taken on Kodachrome Film—in this case, Kodachrome 25.

Visually, this is a simple picture. But it is a very structured image, with interesting elements and ideas. It is not a snapshot, but a promotional image that could be used to advertise many different products.

CONCENTRATING ON THE MODELS' ASSETS

This brother and sister—Lisa and Michael Sweeney—were also neighbors in Pennsylvania. They are both adorable, especially in profile. One day I asked them to pose together. I had been photographing Lisa alone for quite a while.

Naturally I wanted to take advantage of Lisa's hair, so I waited until late in the day and then took this picture with the sun shining through it. Earlier in the day, we had taken pictures of the kids in other situations, always showing them interacting. We all had a great time, and they had lots of ideas for things that they wanted to do. This one was the last situation we shot, and it was my favorite.

All of the shots were taken outside (in the kids' backyard) with Kodachrome 25 and a 135mm lens. The technique was very simple and didn't involve anything tricky— no artificial fill light, filters or fancy set-ups—just one fill card to bounce light in the front. The clothes that the kids wore were clothes they owned.

To determine the exposure, I used a hand-held meter, as I always do. I never use the meter in my camera, because in-camera meters can fool you, especially in a backlit situation, such as this one.

You must learn to really *look* at people around you. Learn to see what aspects, or features, are interesting or attractive. Almost everyone has some interesting feature, some strength. You must learn to recognize those strengths, and use them to advantage in your photographs.

People often say, "I can't shoot good portfolio samples, because I don't have access to professional models." They are wrong. They just aren't looking closely. You don't need professional models and elaborate studios to take good photographs. You can and should learn to use what is around, and the people to whom you *do* have access, especially when you are just starting out and building a portfolio. That's what I did.

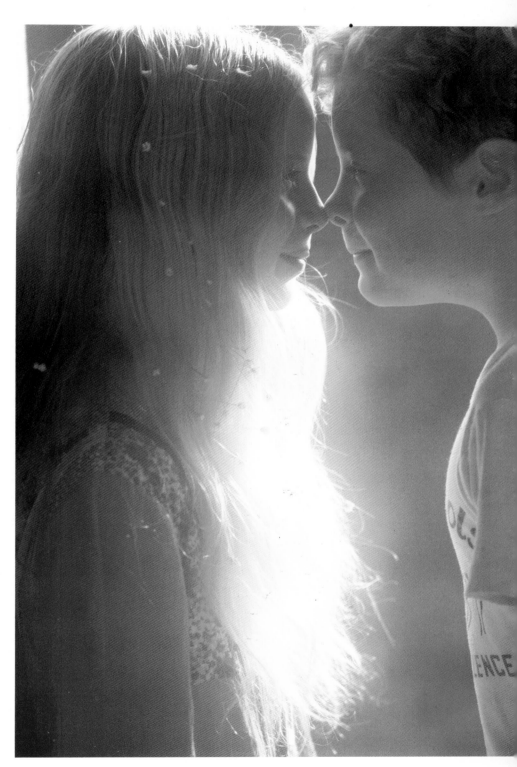

GIVING THE MODEL SOMETHING TO DO

This picture actually was produced as part of my assignment for a photography course that I was taking at the time. The assignment was to shoot a series of pictures that could work for posters of Levi's clothes.

The first thing I did was to buy the blue denim hat with the Levi's label on the front from a local clothing store. For the model, I chose the young daughter of a close friend. She wore a bright red sweatshirt that she owned, because the strong primary colors—red and blue—worked well together. We went to a nearby park to take pictures. I brought only a long lens—a 180mm—be-cause I wanted to come in tight on the girl, and eliminate as much of the background as possible.

However, the girl was very self-conscious and nervous in front of the camera. She kept standing stiffly, looking straight at me. So we stopped taking pictures and I bought her an ice-cream cone. It worked perfectly. Kids love ice cream, the cone looked natural as a prop, and it made the picture more interesting.

Almost every model likes to do something while you're taking pictures. A good prop gives people something to play with, to act with, and helps them become less aware of the camera. That's why I always bring along some kind of prop. Maybe it's only a cane or umbrella, but it can save a shooting. Interesting clothes can do the same thing—help people to feel the part, get them to relax and start acting.

One thing I like most about this picture is the fact that you can't see the model's face. You can't tell whether it is a young boy or girl wearing the hat and eating the ice cream. That ambiguity makes the picture work even better as an advertising image. The model is obviously a child, but the picture doesn't suggest that only girls—or boys—wear Levi's.

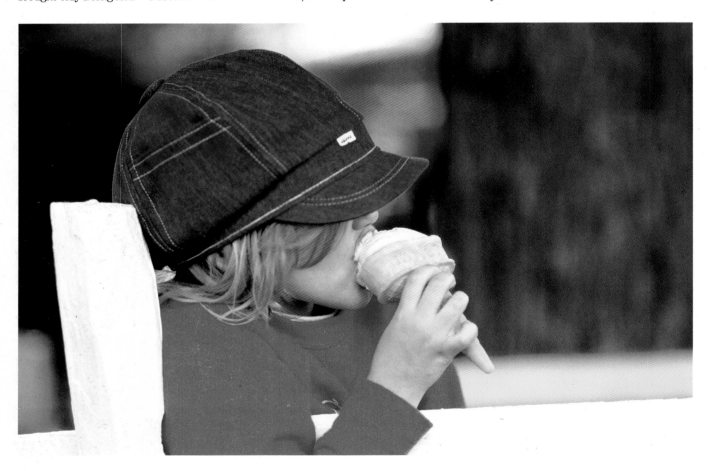

SETTING A SCENE—CREATING A MOOD

These two sisters—Lisa and Monica—loved when I photographed them, as most young girls do. Also, when you photograph people and they like how you make them look, they usually want you to do it again. Often, they even decide to become professional models.

I had photographed Lisa and Monica many times, in many ways, over several years. But this particular time, I wanted a picture that lacked any color—a photograph that was white-on-white, on white. So I asked them to pose together, discussed my idea, and began to set up the situation.

The romantic white dresses came from a department store. We bought them for the photographs, then returned them for credit. You shouldn't always try to return used clothing but this time we did.

The location was in the house of another friend. The house had these great French doors looking out on the garden. The sunlight spilled through the windows beautifully, especially late in the day. I'd kept the doors and room in my mind as a great location for the right picture.

The three of us went to my friend's house. The girls put on the dresses, and I fixed their hair. We had a great time setting up and fussing with the details. People love when you make a fuss over them. Since the girls liked the dresses, they began to get into the proper mood, and to feel special.

I had brought along a book, which was a perfect prop, since it gave Lisa and Monica something to do—pretend one sister was reading to the other. It also added the palest touch of color, which emphasized the lack of color in the picture.

Since the light coming through the French doors was very strong and directional, we set up large white cards on the opposite side of the scene, just outside the frame of the photograph. The cards reflected back a good deal of light, but not so much that the picture became flat.

The result is a very dreamy image. Like most of the other photographs for my first portfolio, it not only shows a particular technique—the ability to produce a strong picture without relying on bright colors—but also immediately brings to mind a number of good captions or headlines. It is an illustrative image that could be used to advertise the dresses, the book, reading in general, or even a particular kind of window.

It is, literally, a picture of two neighbors, but it portrays more than just "the girls who live down the road."

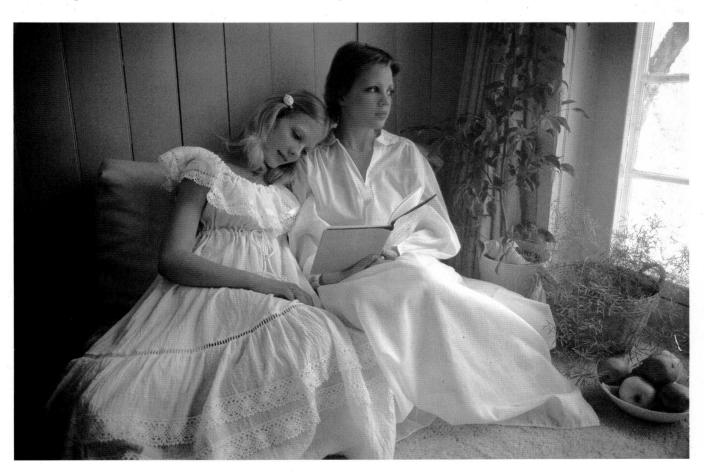

This girl rode horses. She loved horses, trained them, and was at ease with them. So it was only natural to take pictures of her with horses. You often get great pictures when you ask people to do what they're good at, to do what they enjoy best.

Just as a prop can give a model something to play with—and clothing or a particular setting can put a model in the right mood—taking pictures of people on their own ground, doing what they're good at, causes them to relax, act natural and confident. If people are proud of a situation in which you put them, they look in control.

In this case, I wanted to shoot a sample picture that could be used for a cigarette or liquor ad, and decided it would be best to include a couple. So I asked another neighbor, a young man, to pose with the girl and her horse. He became my first assistant when I opened my New York studio.

We shot all afternoon. I took pictures of them riding the horse, standing by the horse, and walking it. As the light and shooting progressed, things started to happen. The pictures began to get better. This is one photograph that worked best.

Of course, the girl never had ridden a horse in a long skirt before, but the dress just made the pictures a little dreamier. I didn't want her to wear jodhpurs and look as if she were really riding.

The picture is heavily backlit, as indeed, many of my pictures are. I love the translucence, and defining highlights on the hair and edges, that result when the primary light source is behind the model.

Backlighting can be very tricky. Unless you expose carefully, and there is light illuminating the front of your subject, you can end up with only an outline of the model. This picture might have been a silhouette, except I overexposed slightly, and added a good deal of fill light from my direction.

What I did—as I used to do often when I started out—was to pull my white station wagon right up in front of the models and cover one side of the car with white sheets. The sheets reflected the sunlight from behind the models into the front of the scene, providing a good deal of soft fill light and allowing me to capture some detail.

I used my Nikon camera with a 105mm lens, and Kodachrome 64 Film. No filters were used.

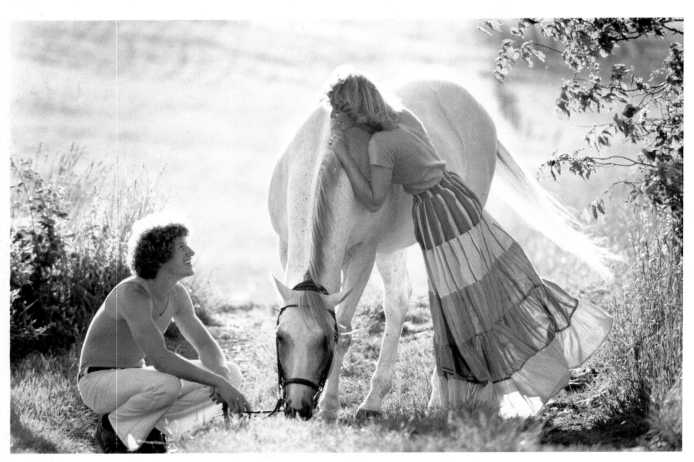

took this picture strictly for the colors. Our barn was covered with old, faded, peeling paint. It looked like the color of lipstick, so I decided to do a photograph that might work as a lipstick advertisement.

The model was Monica, the same girl in the photograph of two sisters reading. She had a wholesomeness—with bright eyes and fine skin—of the kind you see in lipstick and cosmetics ads.

For props and wardrobe, I simply bought a couple of different lipsticks, and pulled out a number of scarves and leotards in colors that might look good with the paint. We went out to the barn, and the whole shooting took an hour. Monica was great. Once I explained the general idea, she knew exactly what to do.

It was an overcast, gray day, and the soft light worked perfectly with the muted pastel color of the barn. There was no need for reflectors or any supplemental lighting to change the scene.

The film was Kodachrome 64, and the lens was a 135mm, without filters. Using this long lens helped to pull the girl into the same plane of perspective as the window frame, and gave the final picture a very flat, two-dimensional feeling.

Like many of my photographs, technically this one was quite simple. Probably the most difficult part was cleaning the window. What makes this picture work is the idea—all the colors of the scene reinforce, and harmonize with, the color of the lipstick. To repeat myself, what matters most is the idea. When breaking into advertising photography, it is especially important to show samples that have a concept, that can stand alone without words, and give art directors ideas they may apply to their products.

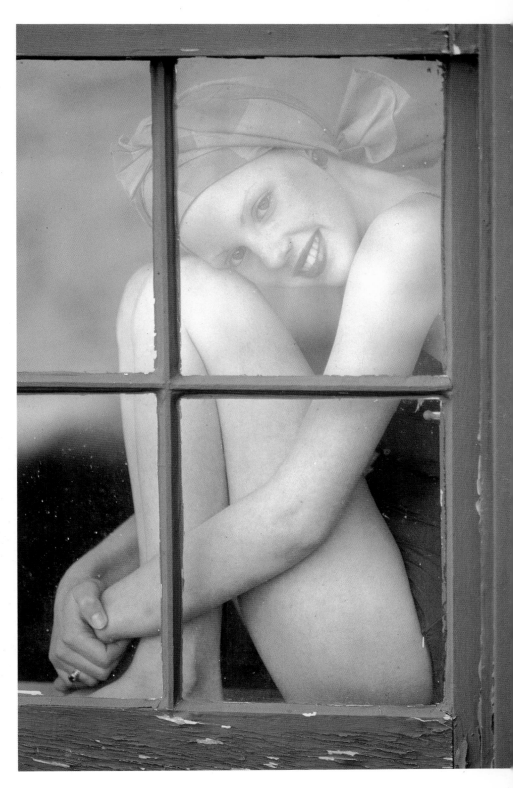

This is Rick Lippincott, the husband of a good friend of mine. Rick and his wife now live in Texas but during the years I was putting my first portfolio together, they had a farm near us in Pennsylvania.

When I first asked Rick if he would model for me, he said he didn't like having his picture taken. He felt nervous in front of a camera, and thought that he never looked good in the final photographs. I felt Rick would make a great model, so I cajoled and cajoled. Finally, he consented to letting me do a few simple portraits of him.

One of the pictures from that first session—the shot of him in a polo shirt—is shown here. It was taken in the backyard right behind their house. Late in the day, I positioned Rick with the sun behind him, placed one large sheet of white cardboard in front of him to reflect some light back on his face, and used a 135mm lens with no filtration. The film, of course, was Kodachrome 25.

Rick liked those first pictures so much he consented to model for me a second time. Soon he was asking when we could shoot again. I ended up doing quite a few tests with him over the next few years.

Once Rick found out he could look good in front of a camera, he began to enjoy being a model and he became better and better at it. He loosened up and started to act for the camera and he even began to suggest ideas and situations for pictures. As time went by, we gradually began doing more and more complicated pictures that were highly structured and propped illustrations.

The picture used in the advertisement for Bell's Scotch Whisky has a funny story. The idea was to take a picture of Rick as a "country gentleman farmer." Rick already had the corduroy coat, the beard, and the cane. He also already owned a farm with lovely fences, so propping and styling was easy. It was a natural picture to take.

Because it *was* Rick's land, and because he had begun to feel confident in front of the camera, the picture came out perfectly. Somehow, you can just feel the sense of security and pride in owning land beaming from his face.

Like the rest of the shoot, the shot used in the ad was taken just as a test, later to become samples in our portfolios, but I also decided to file it with The Image Bank stock photography agency. At least four or five years after the shooting, Ogilvy & Mathers bought the rights from The Image Bank to use the picture in this national advertisement. Both Rick and I were ecstatic.

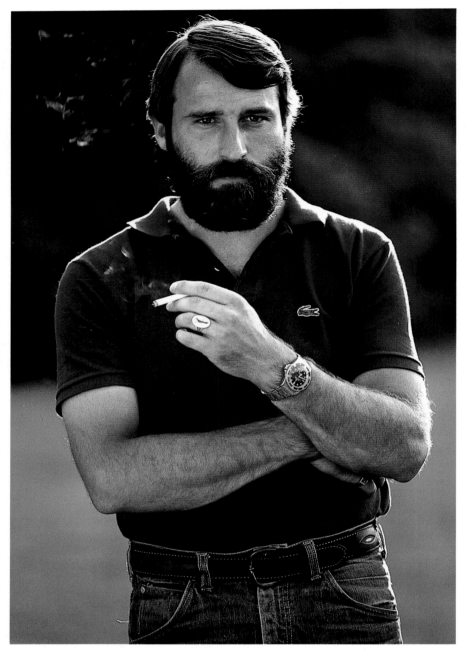

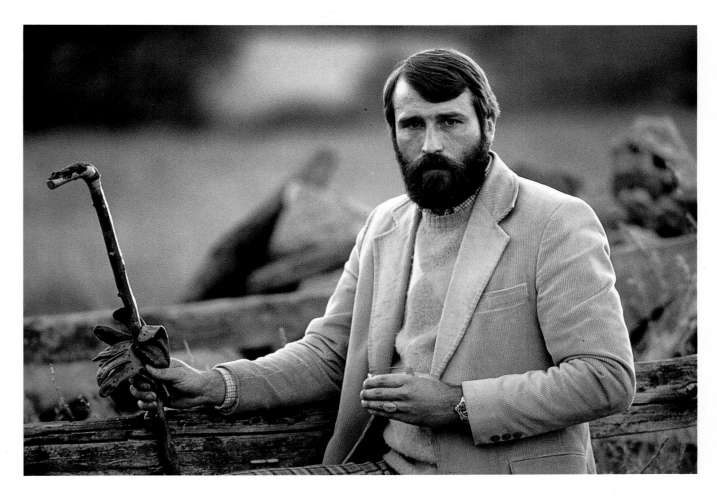

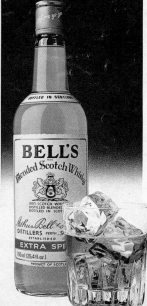

the best selling Scotch in Scotland.

They must be bought in Spain, shipped up here to Scotland, and inspected in Bell's cooperage.

As you can see, a great deal of extra bother goes into Bell's. All to be sure it keeps its malt whisky taste, but smooths away any bad-mannered harshness.

Without all this fuss, without Scottish barley, extra malt whiskies, double blending and double aging, and oak sherry casks…Bell's

would be just another whisky of no particular character or polish. And we Scotsmen, who have our pick of the stills, would give Bell's our backs.

Please accept our invitation to drink our very own Bell's, the Scotch whisky we Scotsmen make our national favorite year after year.

Stop reading about Bell's, and taste it.

Bell's. The best selling Scotch in Scotland.

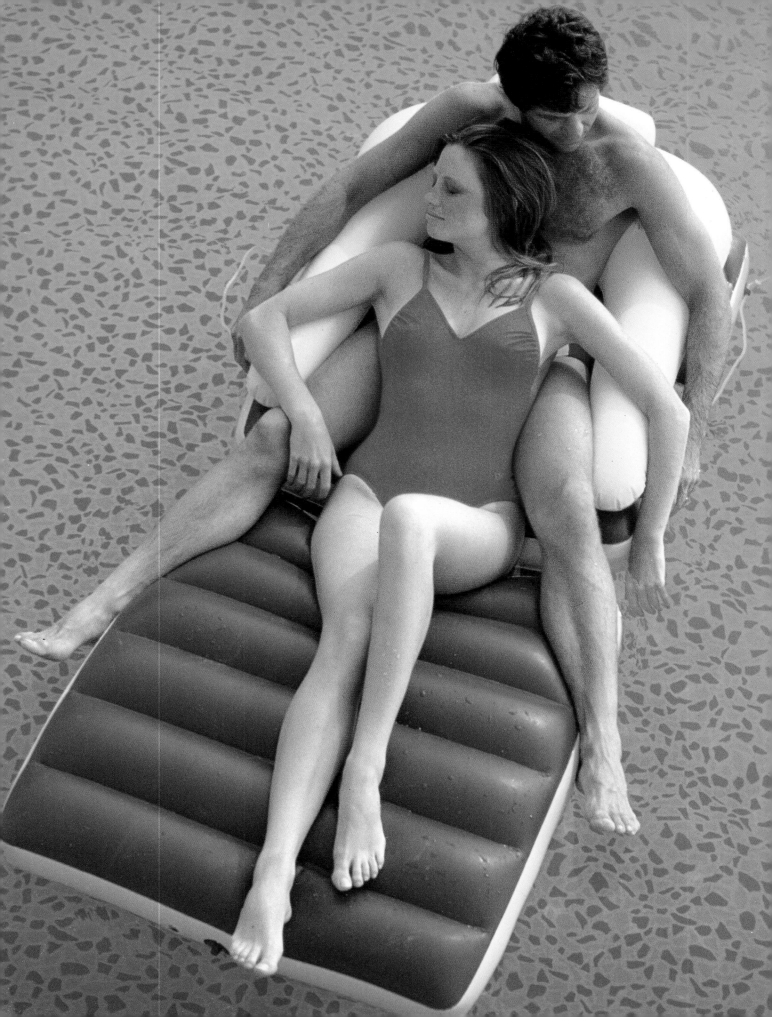

Chapter 2

THE IMPORTANCE OF TESTING

A "test" session is a photography shooting you do for yourself—to produce portfolio photographs, pictures you can use in advertising, and shots that will get you paying jobs. You come up with an idea, get other people involved, and all agree to do the pictures without a fee. Everyone usually works for free, and benefits in other ways.

In my opinion, testing is one of the most important parts of professional photography, and it should be an ongoing process. No matter how busy or successful, you should never stop testing. You must make time for your ideas. I personally would be very frustrated if I didn't "do my own thing" occasionally.

A test offers models, stylists, hair and makeup artists, photographers, and others the opportunity to try out ideas. It allows you to develop and expand your portfolio. Sometimes you produce pictures that later are bought for reproduction, and the test more than pays for itself.

In many ways, a test is a practice shooting. It is a chance to experiment, to try out new approaches and techniques. It is a time to try out ideas that might work, but that clients may not pay you to produce.

Tests allow you to do the type of photography you really want to do and can open doors to producing that work as a paid assignment. Tests are a way of giving clients ideas, showing approaches they may not have considered. Tests show the type of work you feel you are capable of doing, while tearsheets and paying jobs show only what other people hired you to do.

Tests are often expensive to produce, but can be well worth it. Besides the cost of the film, you sometimes have to buy or rent the appropriate props and clothing. You may have to rent special equipment, and make additional prints for the people who help you, although I usually give original slides.

For the best results, you must treat a test as if it were a real job, a paying assignment with a client peering over your shoulder. You should have a definite result in mind before you start shooting, although you may adapt to, and work with, the situation once you start. It's a good idea to set up a schedule, and follow it. You should work hard, and make sure everyone else does, too. Once you've gone through the expense and effort of setting up the test, it makes sense to take a lot of pictures.

I do a great deal of testing, and love it. I sometimes hear other commercial photographers say, "I never pick up a camera unless I'm paid." But I just can't understand that way of thinking. If I didn't pick up a camera between assignments, I wouldn't get any assignments. I get a great deal of work as a result of tests, and the pictures also sell wonderfully as stock photographs.

My ideas for tests come from many different places. I often get inspired by something in a store or a piece of clothing. I get inspired by paintings and movies. My ideas come from store windows and displays or when I'm challenged by an unusual technique someone else is using. Sometimes other people, stylists or models, come up with the idea and suggest we do a test.

did this test with Chaz and Maija. The idea was to get samples that could be used for cigarette or liquor advertising.

The location was suggested by an intern, Hillary, who was working with us during summer vacation from college. It was her parent's beach house on the New Jersey shore. I had been looking for a good beach house location to use for some tests. One weekend, she went there, took some pictures, and brought them back to the studio. The minute I saw them, I knew the place was perfect and arranged to go see it.

The whole shooting took only four hours, but we moved quickly. Chaz and Maija worked really hard. Maija did her own hair and makeup, which was good because she was fast. I did the styling.

We all drove out to the house in my van one bright Saturday morning. We took lots of clothes and bathing suits. Almost all of the necessary props were at the house— thank God—but we stopped in town and brought fruit, flowers, bottles of wine, cheese, and other things. After we'd finished shooting the food, we ate it for lunch.

I try to never let anything go to waste!

We started shooting at about noon, and continued until sunset. During the bright middle of the day, we photographed inside the house; as the light got better, we went outdoors to the beach. Toward the end of the day, we worked by the neighbor's pool.

All the pictures were taken with available sunlight, and using an occasional reflector card to soften the shadows. The light was so bright that even the "breakfast" shot inside the house needed nothing more than reflectors.

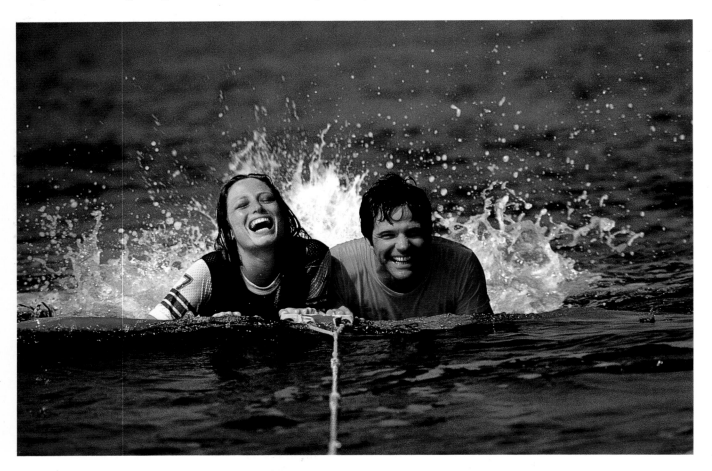

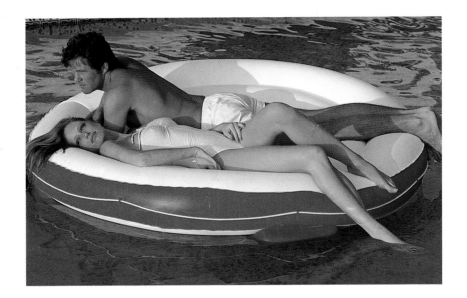

The pool pictures are a funny story. There was quite a current in that pool, and the raft kept floating all over the place, so my assistant, Shawn McGee, jumped in the pool and held the raft still. He hid behind Chaz and Maija, and treaded water for what must have seemed like an eternity.

The pictures from that day sold many times as stock photographs through The Image Bank. Each time one of them sells, Chaz and Maija make a little money. I'm sure that day has more than paid for itself.

Chaz and Maija are great models, as well as good friends. They know just what to do, just how to act. I warned them on the way out that we were going to work very hard, and they certainly did, especially Maija. It's incredible how many different ways she can look. She can look like the girl next door, or look happy, sultry, or sexy. It's hard to tell she is the same woman in all these pictures.

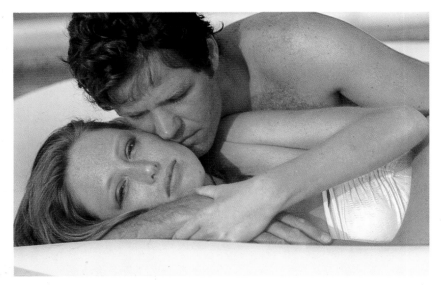

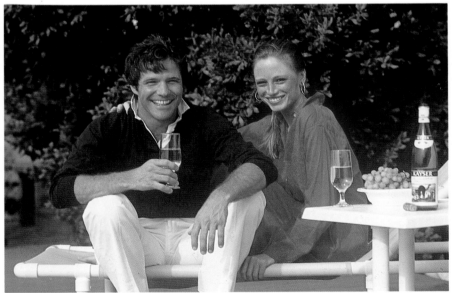

This is the most successful test I've ever done. It is a picture full of ideas, one that gives ideas to art directors. It shows an unusual technique, a unique approach, and it could advertise many products—perfume, stockings, shoes, shampoo, or clothing.

One of the reasons this picture is so successful is that it shows a unique approach to a common subject. I've seen lots of pictures of swings, but never swings used this way. Swings are always photographed outdoors, usually under trees.

It's difficult to come up with a really different picture, since everything has been photographed so much. I rack my head for new ideas all the time. If you can think of something that hasn't been photographed, or a completely new way of photographing something, by all means, take the picture. People will remember it.

The technique used here—mixed strobe and tungsten lighting with a great feeling of movement—is also unusual. It shows we can handle a difficult kind of shot, and gives art directors confidence in our technical abilities.

I guess that technique is what inspired this picture. For a long time, I had wanted to combine mixed lighting to produce a sensation of motion. The idea of the swings offered the perfect opportunity.

The swings were hung from hooks on the rafters in the studio. The background was black seamless paper, placed a good distance behind the models. We positioned one big umbrella with a strobe head in front, and placed tungsten spotlights on the two sides. We held the camera's shutter open as the models swung, and then manually popped the strobe when they reached the apex of the swing. That way, the continuous tungsten light registered on the film as a golden blur, and the strobe froze the action. We actually did this shooting twice, two nights in a row. The first night, when my assistant tied the swings, he left pieces of rope dangling from underneath the seats. I was so busy concentrating on the models and lighting that I didn't look closely at his work. When I got the chromes back, the loose strips of rope looked horrible. I knew they would always bother me, so I asked the models—Nicky Winders and Ken Miller—to come back.

Nicky and Ken were great. They not only came back, but they swung for hours. My kids, Jordie and Kendra, even got involved. They stood on the sides of the set and pushed the swings off, and loved it!

I used a 105mm lens, and was jammed back into the far wall of the studio. We took out the workbench to give as much distance as possible, but I wish I had been even farther back. I would have liked a little more space around the edges of the picture.

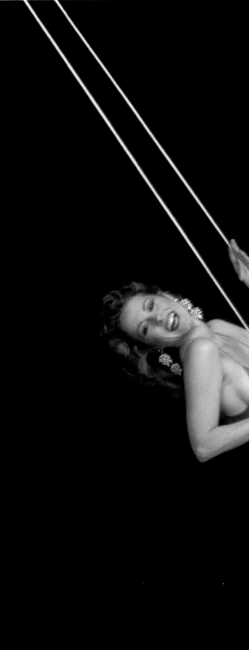

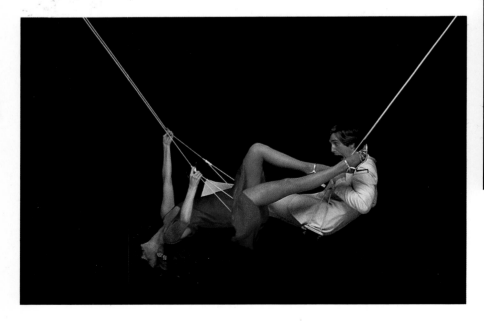

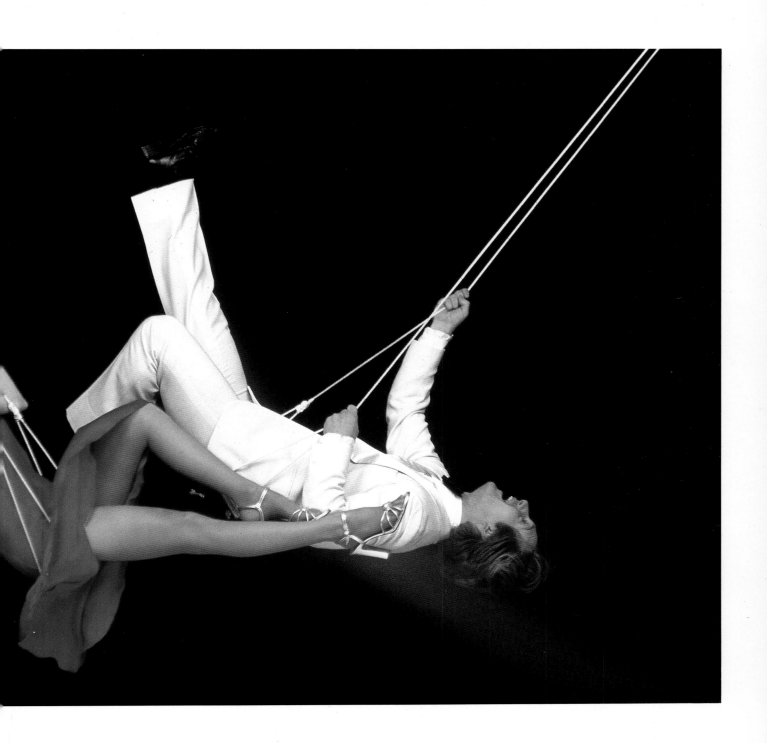

This is a test I did on location. Again, it was the type of photography that could be used to advertise liquor or cigarettes—or simply romantic moods with a couple in an atmospheric setting—but this time in more of a "period" setting. The test with the couple at the beach house was about a contemporary, healthy, and energetic couple having fun, while this one was a mood piece.

We spent a good deal of time and money on this test, but it was worth it. Often when people ask to see our portfolio, they tell us to include the "train series." Art directors seem to love it, and it has played a part in getting me a number of jobs.

The male model was supposed to be Chaz, but at the last minute he got a paid booking. Chaz's modeling agency (Zoli) sent another model in his place—Russell Aaron. I was upset about the change at first, because I had envisioned Chaz in the photographs. In the end, however, Russell was perfect—tall and dark, skinny, but with a full face. When he put on that old-fashioned suit, it fit perfectly. The female model was Winifred, from Kay Models.

I had this idea of photographing a couple on a Victorian-style train for a long time. I first went to find out about shooting at the train station in Hoboken, New Jersey, right across the river from New York City. There are some wonderful old cars stored there, with the original wicker seats and everything. The station itself is also marvelous, very old-fashioned with wonderful architecture. But there were all sorts of rules about photography. We would have to pay a large location fee, and only would be allowed to shoot at certain times of day. When I said I wanted to use a fog machine, the answer was a flat no. It was out of the question.

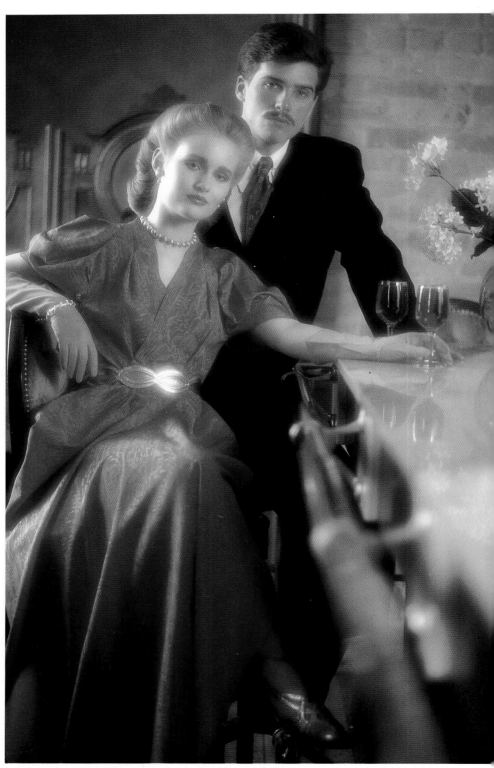

I photographed this test two ways—"grainy" and "straight." I felt the romantic, period feeling of the scene might lend itself to graininess but you can never be really sure about using such an extreme technique until you see the results. In the end, I feel the "straight" Kodachrome picture works better. For information on how I achieve the kind of grainy effect you see on the far right, please see page 128.

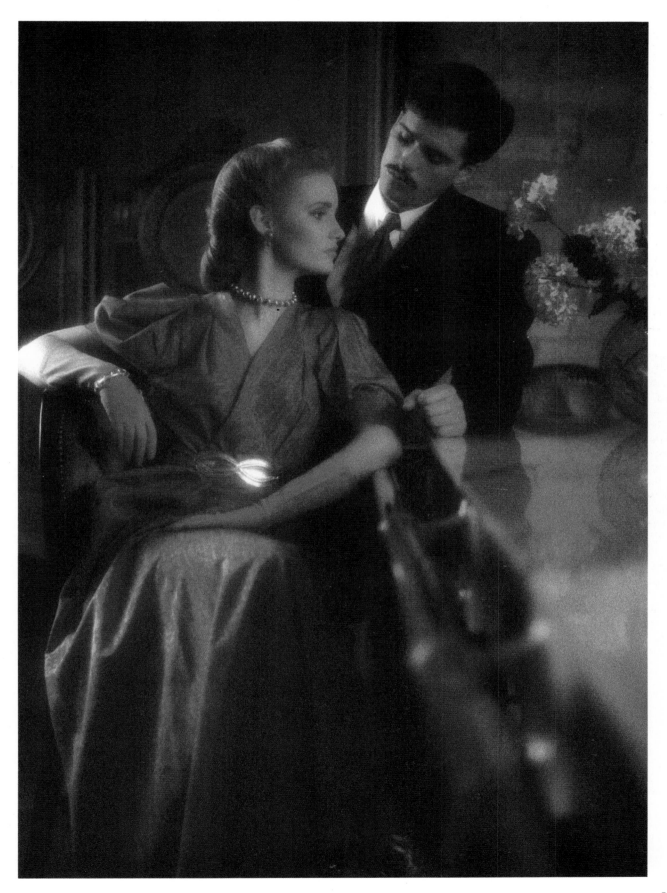

I was still going to shoot at Hoboken when a friend told me about this old train station in Pennsylvania that was now a hotel and restaurant. There was a collection of authentic old railroad cars in which you ate, and you even stayed in old Pullman sleepers.

David and I went to see the place. We ended up staying the entire weekend. It was amazing. The cars were completely restored and authentic. They were quite plush, with all the right details: cut-glass lamps, old vases, velvet upholstery. When I asked the owners if we could come back to take pictures, they said, "Sure. Any time." The only restriction was that we couldn't interfere with the lunch crowd.

The six of us—Winifred, Russell, David, Jody, one assistant, and I—drove down in the van one morning. We had rented the fog machine and clothes in New York. The clothes weren't copies or costumes, but antique clothes. They were tiny. Women in those days had small waists and shoulders. Luckily, Winifred is small. Bigger girls usually have to be fitted by the woman from whom I rent antique clothing. She opens up seams in the backs, and sometimes even gives the models waist cinches, and are those uncomfortable!

Jody Pollutro did the hair and makeup, and helped with styling. Russell's mustache is fake, the same "traveling mustache" you see a number of times in this book. The lingerie was mine, and the red coat I borrowed from my studio manager, Judith.

We brought along a great deal of lighting equipment, and there is a lot of strobe lighting in these pictures. But we used the strobes very subtly, very softly. We only added additional lighting to raise the general illumination, and were careful not to overpower the light from windows and lamps. We metered for existing light, set the strobes at low power, and diffused them through large sheets of parachute silk. Everything was shot at slow shutter speed, with a No. 1 diffusion filter for a soft, romantic look.

We photographed everything two ways—first on Kodachrome 25 Film, then on Ektachrome Film, which we later push-processed for increased grain. In the end, the straight pictures, without grain, seemed to work best. We also shot numerous variations of each situation, sometimes with different lighting for different products.

The people who ran the place were very helpful and friendly. I sent them a batch of color prints, which they loved and now are hanging all over the hotel.

Testing on location can be fun. A place can give you all sorts of ideas, and unexpected things happen of which you can take advantage. The existing light can be great, too.

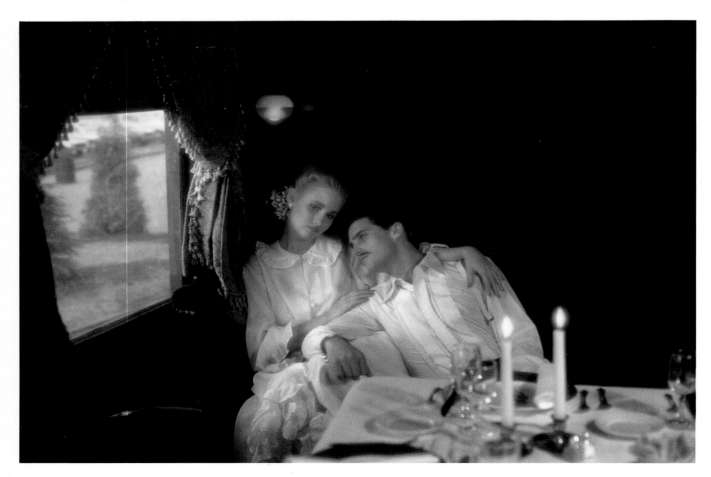

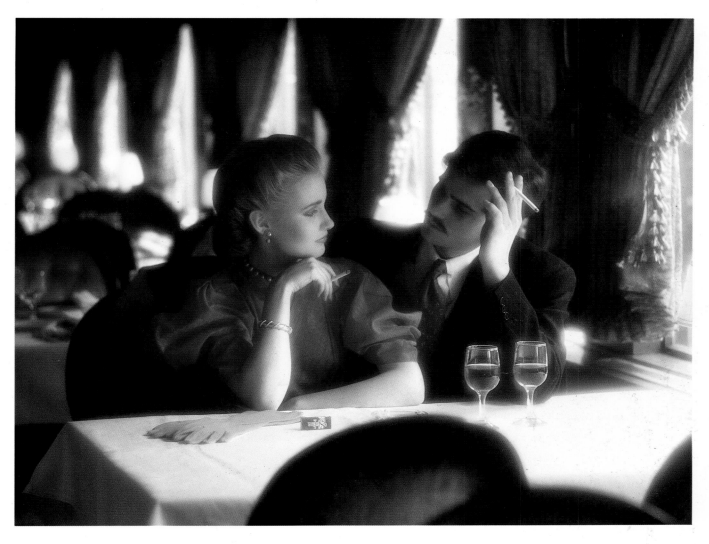

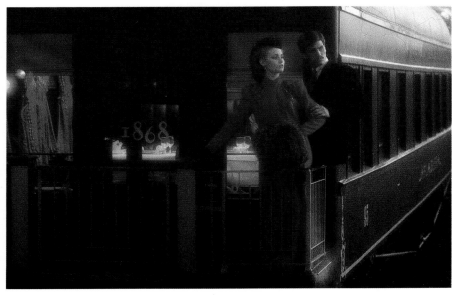

This test was actually a film test. Kodak had just introduced its Kodachrome 64 Professional Film and asked me to try it. We were sent a case to use any way we wished and all that was requested in return were our honest comments about how it compared with the Kodachrome 25 Film.

I decided to do some beauty tests with the film. The idea of the musical instruments was inspired by a photographer who works in my studio, Barry Schine. He was shooting still-life photographs of a French horn with colored streamers coming out of it. I loved the way the horn looked.

It's nice to give models some props to work with. In a lot of cosmetic ads, the girls are doing something, not just looking at you. They have a telephone in their hands, or a pen, or mirror. We decided to try different models with different instruments.

Barry had been photographing a gold horn, and offered to lend it when he was through. But for Angie's light hair and coloring, we felt a silver horn would work better, so we rented one. We also had to rent all the other instruments.

This picture was lit with a bank light on a boom right above Angie. The horn was sitting on a white table. The table itself reflected a good deal of fill light, but for a little more kick, we placed a bright silver reflector on the top. The background was simple, white seamless paper, very brightly lit by two umbrellas for a clean white.

The polished horn was very shiny, so we positioned black flats on both sides of the set, and a large white flat behind me. The flats reflected in the surface of the horn, especially on the edges, and added definition. They gave it shape. Without the black reflections, the horn would have looked very flat. We hardly ever use black flats with beauty photography—they can be unflattering to the model—but this time, they worked.

Kodak bought advertising rights to this picture after we had taken it. It was used on the cover of a brochure on the new Kodachrome Professional Film. I was surprised this picture was chosen, since it isn't typical of Kodak pictures. It contains practically no color, and Kodak pictures usually have reds, bright yellows, and deep blues—the three primary colors.

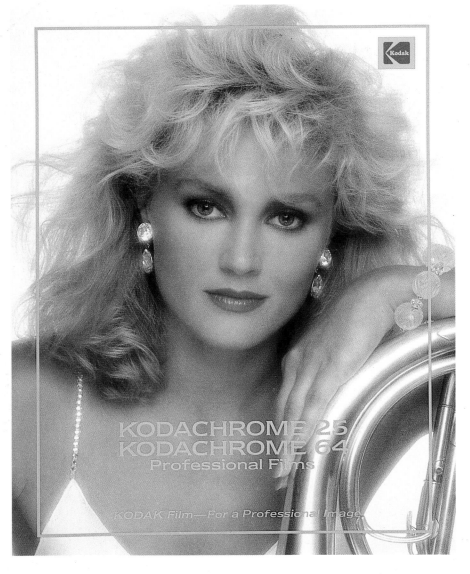

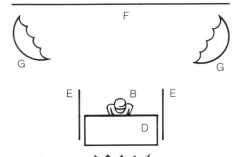

A: 35mm Nikon camera with 105mm lens
B: Subject
C: Main light (white 42″ umbrella)
D: Silver fill card
E: 4′ × 8′ black fill cards
F: 9′ white seamless
G: White umbrellas

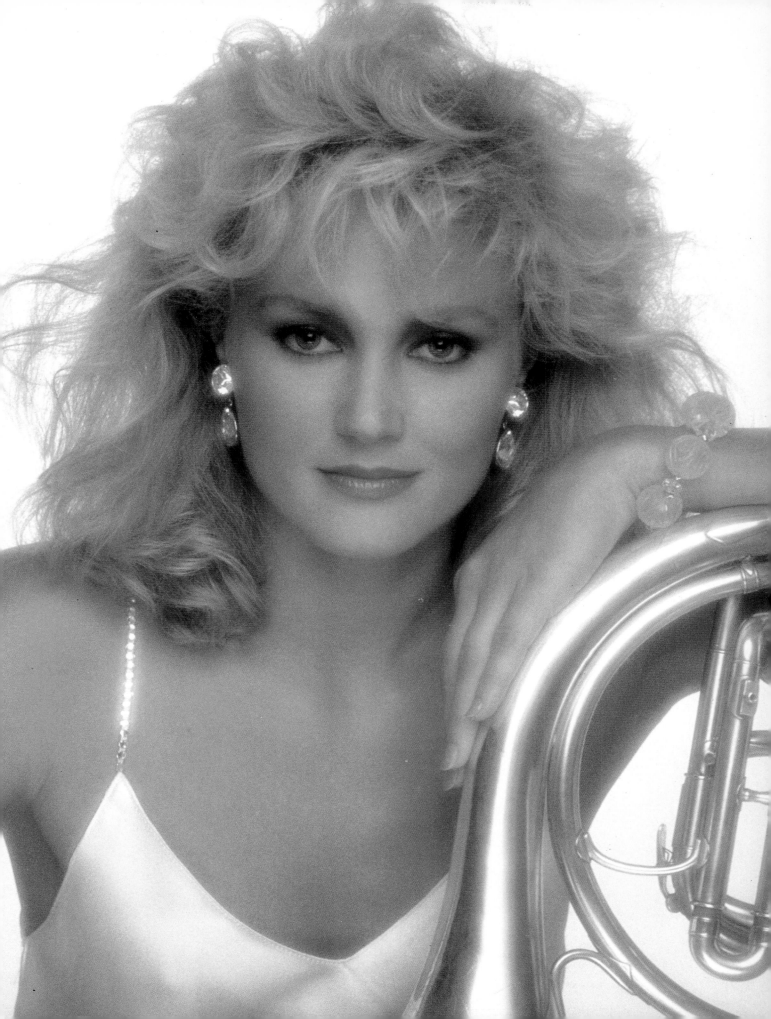

This was another test photographed in the studio, but entirely different from the beauty photographs of models with musical instruments.

This test was inspired by the backdrop, the background painting. Charles Broderson, a backdrop painter in New York, wanted to produce a catalog of his photography backgrounds available for rent, so he asked different photographers if they would test with his backdrops. He told us we could choose any we wanted to use in exchange for extra chromes. We picked some fancy French doors, a sky at sunset, a painting of the pyramids, a cloister scene, and this huge canvas painting of an old-fashioned country landscape.

This test probably cost as much as any test we've done. We rented the costumes—real antique dresses and accessories—and, as we got more involved, also rented authentic props like the carriage and bicycle.

We started out planning to use a sheet of brown seamless paper for the floor, but it didn't look right. (Finding, or building, the proper floor is a problem you often encounter when using backdrops. If you don't have the proper floor, you are restricted to taking pictures of models from the knees up.)

We needed something to tie the floor in with the backdrop, and decided to use leaves. We weren't trying to make the pictures look completely real—the backdrop doesn't look completely real—but we needed an additional element to tie the two together.

We sent an assistant out to find leaves. He went to a prop house, Modern Artificial, and bought a big plastic bag of fallen leaves that cost $85. I couldn't believe it—$85 for a bunch of leaves somebody picked up in their backyard! If I'd known the cost, I would have gone to the park and raked them up myself. But it was winter, and we had no choice. We still have that bag of leaves in the studio, and have since used them for a paying job.

This was a huge backdrop, probably about 12 feet high by 18 or 20 feet wide. You could use parts of it, as well as the whole scene. (Some backdrops are only four feet square, designed just for head-shots.)

The backdrop was illuminated evenly by four strobes bouncing out of four umbrellas. The models and set were lit by a huge bank with six or eight heads in it. There were hairlights above each model, strobes in silver umbrellas with Pellon, a parachute material that softens the light. The hairlights were down lower than usual, because the girls had very dark hair that just seemed to suck up light. In this type of situation, we pull the hairlights down closer, rather than turn up their power.

The shooting took about six hours, and we did many variations. Once everyone was there, and everything arranged, we decided to get as much mileage out of the situation as possible. You can't afford to set up this kind of test and then shoot for just two hours. But we had fun. As the shooting went on, boyfriends and husbands came over, and then we all went out to dinner in one big group.

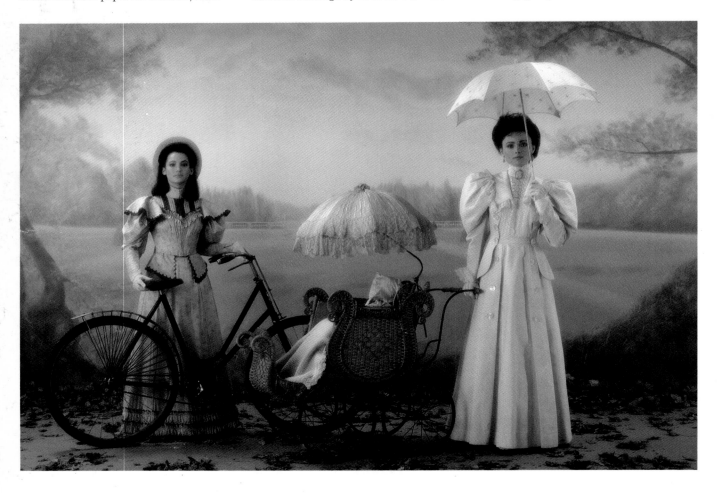

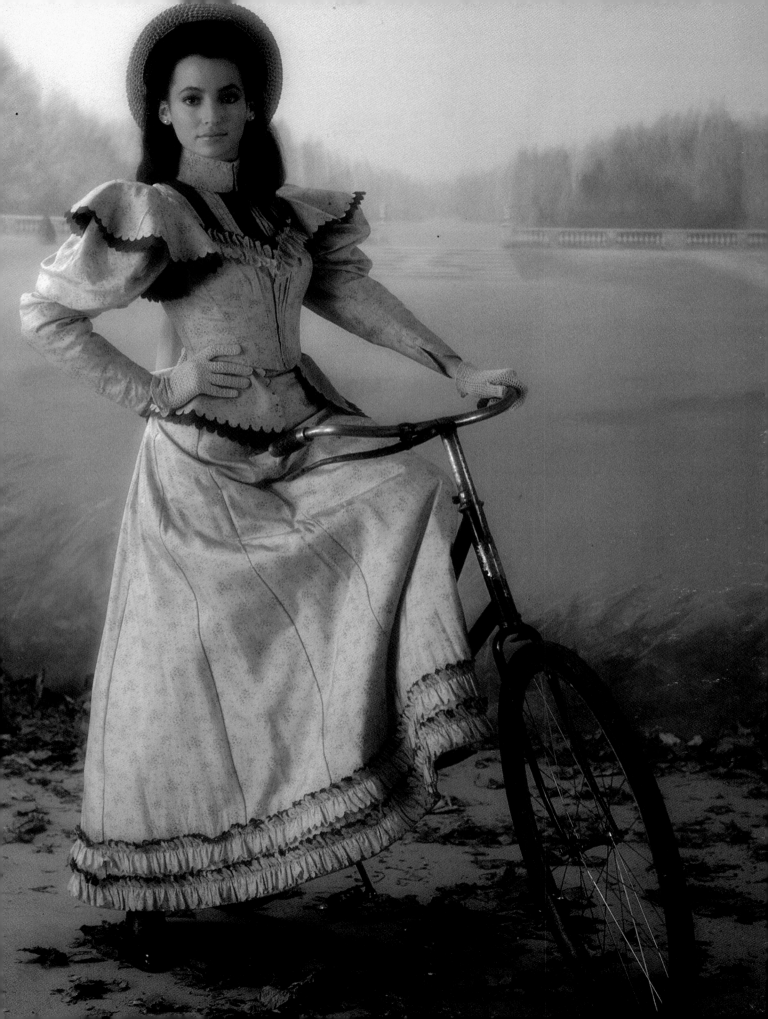

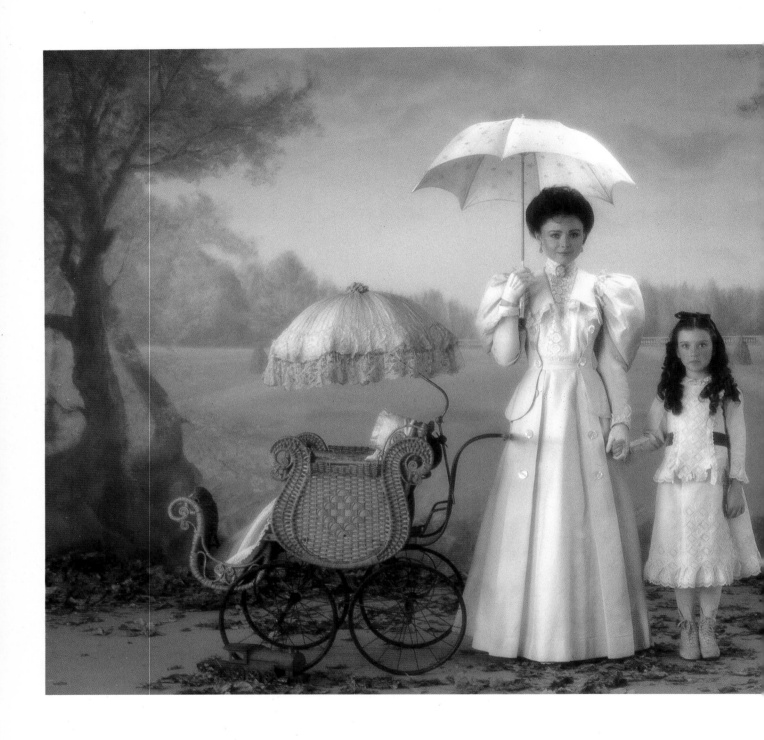

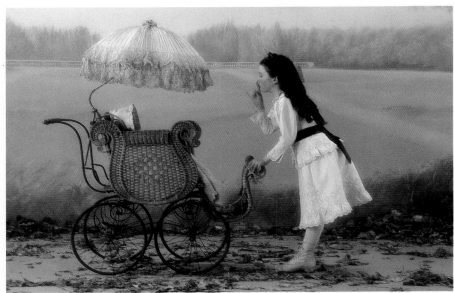

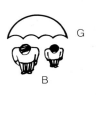

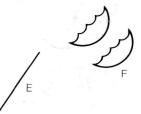

A: 35mm Nikon camera with 85mm lens
B: Subjects
C: Parachute diffusion material
D: Six Calumet strobe heads with 9"
reflectors
E: 4' × 8' white fill card

F: Two 42" white umbrellas stacked one on
the other to light up the right side of the
background.
G: 42" white umbrella (hairlight) directly
overhead the subjects
H: Background

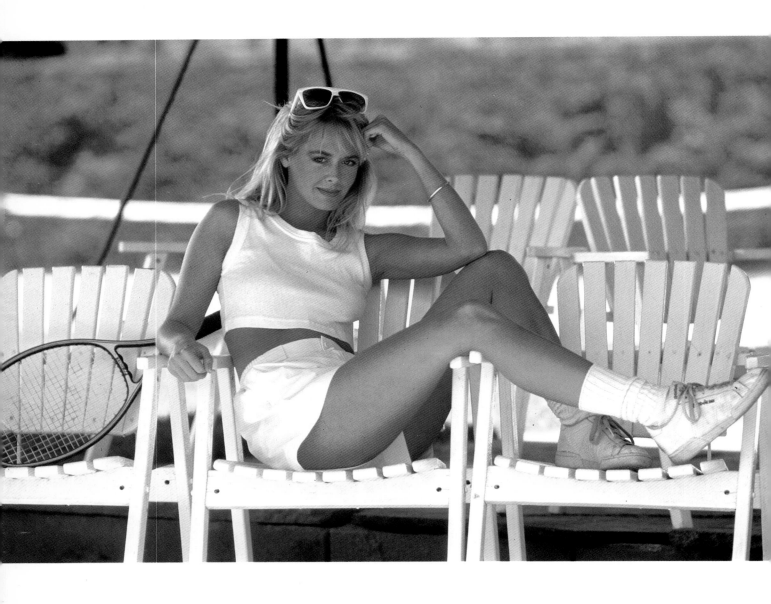

WORKING WITH MODELS

The most important talent you can possess as a professional photographer of people is skill in working with people—skill in relating to them, in making them feel comfortable and confident.

If you're not good with people—even complete strangers—you won't get good pictures of them. If you're shy and introverted, or if people don't like you right away, you probably shouldn't photograph them for a profession—at least not for advertising. You might be more successful, and happier, as a still-life or landscape photographer.

The most important thing in your pictures is how the people look—whether they are happy or nervous, confident or scared. The way people look is completely related to how they feel in front of your camera at the moment you photograph them. It is a simple point, but a very important point, and worth remembering.

This is true not only for friends, neighbors, family, and business acquaintances, but also for professional models. Even though professional models are more adept at acting for the camera—more experienced at posing and knowing what looks good—they often need cajoling, coddling, and communication in order to do their best. They need to like the photographer they are working with—have some relationship or rapport—to really feel, and look, great.

In my years in the business, I've developed good rapport and a relationship with certain models. We have become good friends who enjoy each other's company and are sensitive to each other's emotions. It is because of this established relationship that I work with these same models again. I know we'll have a good time, *and* get good pictures.

The best professional models are capable of effecting an "attitude"—an indescribable "look" that can become the focus of an entire picture and cause it to work. That look is magic.

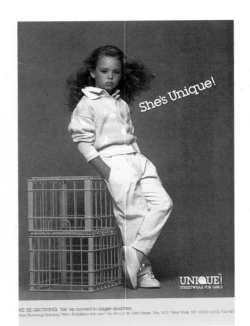

These pictures are from a studio shooting I did for Unique, a children's clothing manufacturer.

The model—from Ford Models Children's Division—was incredible. Not only was she amazing to look at, with gorgeous eyes and lovely long hair, but she knew exactly what to do. She could move and pose beautifully. I wish some older models could be as good as this seven-year-old child.

The idea for the photograph was simple—gray seamless paper, with something pink for the model to lean against. However, simple seamless paper is also the hardest thing for a model to work with. The model has to stand there, in "nowhere land," look directly at the camera, and do something to make the picture come alive. It isn't easy, and most models can't do it—one of the reasons I don't like to shoot on plain seamless paper—but this little girl could. If I worked with more models like her, I'd take more pictures on seamless paper.

These pictures show how a great model can create good photographs seemingly out of thin air. The photographer has little to do but catch what the model is doing.

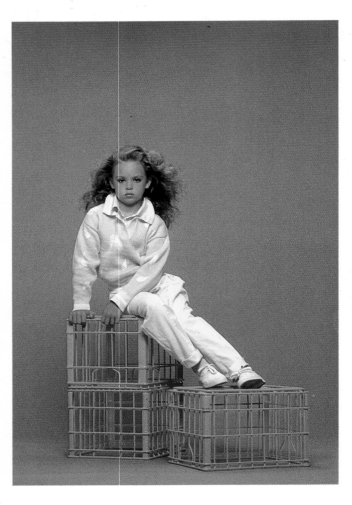

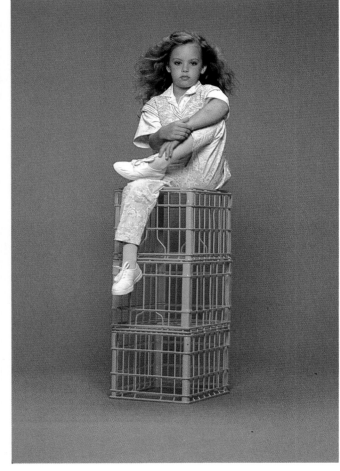

This picture was taken as a test, one of my first samples. The male model is my good friend Chaz, and the female model is me.

We had planned to use a beautiful young girl in the picture, who had gorgeous hair, a lovely figure, and who I had photographed before. However, she was young, inexperienced, and stiff, and when I asked her to kiss Chaz, she got all flustered. I guess she'd never kissed a guy and just couldn't get the pose right.

After taking about two rolls and her pose still wasn't right, I stopped shooting, put on the dress we'd brought, and got in the car. David took over as photographer. I had meant to show what I wanted her to do, but I ended up being the model.

The idea for this photograph was inspired by a neighbor's driveway near our country house in Pennsylvania. I loved the pattern of the stones. The car was borrowed from another neighbor, and we spent hours washing and waxing it. The yellow flowers were picked in a nearby field when we realized we needed another spot of color in the picture.

We got the unusual overhead angle by shooting from the bucket of our farm's tractor. We put the tractor in position, hoisted the bucket up, and then drove the car right underneath it. The picture was taken under available sunlight late in the day, with a 28mm lens (in order to include the entire car) and Kodachrome 25 Film.

As you can guess, the whole neighborhood got involved in the shooting. One of the boys who cut our lawn worked as an assistant and enjoyed it so much he later moved to New York and worked in our studio for a couple of years.

This is another example of a photograph that covers a lot of bases and can be applied to many products. Next to the photograph of the couple in the swings, this shot of us kissing has been my most successful sample.

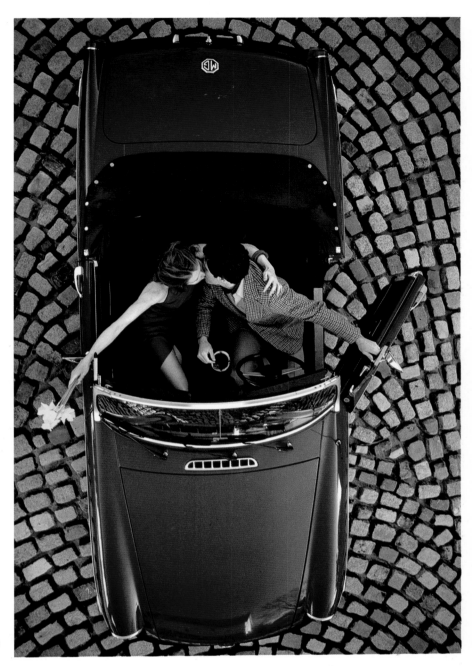

Women are tricky to photograph well, because everything—hair, makeup, and clothing—has to be just right. With men, things don't have to be quite as perfect. On the other hand, you can dress up women more, do more with accessories, and so on.

These are two very different pictures of women. Both are taken outdoors under available light, but they have very different feelings.

The girl in the water is Christy Finchner, who is now Miss U.S.A. She's absolutely gorgeous, a good model, and was really young when we took these pictures.

The way in which I met her is a funny story. I was going to do a test with a male model, and suggested he bring along a girl. The girl he brought was Christy, and she was just a high school kid. I never did any more tests with him, but I did a lot more with her. I must have gone to her house in Connecticut at least three weekends during that summer. I'd go alone, without any assistants or hair and makeup people, and she would pick me up at the train station. Within a year, she was working as a model professional with the Elite agency. Now she's with Ford Models. She was a sweet kid, and a born model. Of course, I love her smile in this picture, but I really love the fact that her eyes are closed. It makes the picture so sensual.

The woman in the fur coat is Lynn Jefferson, and she was older, obviously. The fur coat was mine, and the gloves were hers. Lynn did her own hair and makeup, and she had a great attitude that day, which really makes this picture work. It's something about her lips and the look in her eyes. (She was quite small, the coat was too big, and it was a cold day, so what she's doing was totally appropriate.)

In both pictures, the models had something to work with (the coat and the waves) and were in interesting locations and situations. I let them do what came naturally, which was easier than if they had been posing in the studio on a sweep of grey seamless paper.

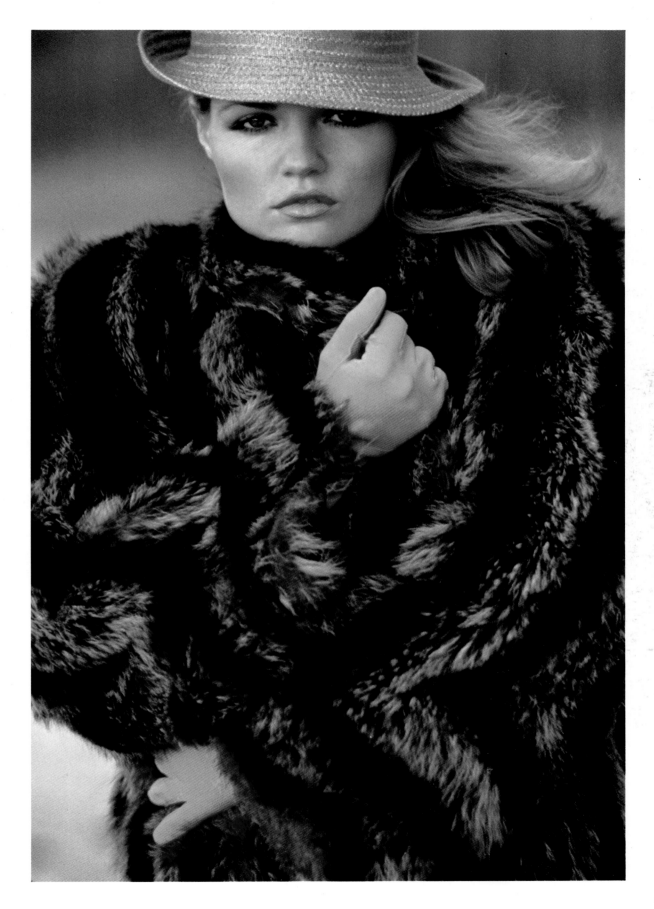

This is Penny Baker, a good friend and a girl I have been photographing for a number of years. I took her to Maine when she was 15. (The picture of her with Damien in scuba gear is from that year.) When Penny was 19, she was selected as the centerfold playmate for *Playboy* magazine's thirtieth anniversary issue. Now she's acting in movies. "Lucky Penny" is her nickname. She's very flexible and friendly, and I've taken so many pictures of her that maybe someday we'll put the best ones together and publish them in a calendar.

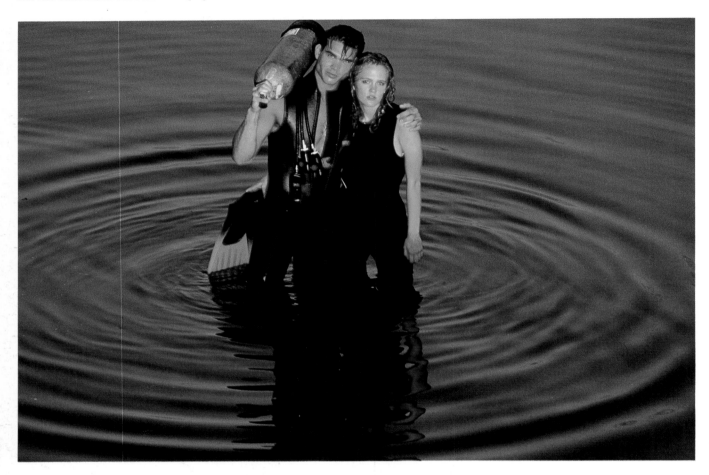

The picture of Penny on the motorcycle with the rose tattoo was taken when "PM Magazine" did a television story on me and my studio. I had to put together a shooting for the TV people to film. I think Penny was 16 then. Jody Pollutro did the hair and makeup.

The motorcycle belonged to Jody. We brought it up into the studio and spent hours cleaning and polishing it. The smallest spot of dirt on a prop can stand out in a photograph and destroy an otherwise good picture.

The background was a large sheet of black velvet. The lighting was two strobe heads in silver-lined umbrellas. One umbrella, the primary light, was on a boom almost directly in front of Penny—just over my right shoulder. The other umbrella was above her—a hairlight to brighten her hair and outline shoulders and arms. As you can see from the glow off her earrings (and bright parts of the motorcycle), we used a No. 1 soft filter to diffuse the picture.

We had big, black flats on both sides of the set. I usually don't use black flats when photographing a woman—they aren't as flattering as white flats—but we needed more definition in the chrome of the motorcycle. The black reflected on the edges of the chrome, and gave it some shape. (White flats would have reflected highlights, even against a black background, and caused the chrome to photograph as an almost even, flat, white.)

The picture of Penny in the rain was taken earlier, and may have been the first picture I ever took of her. She's wearing the same shiny bathing suit in the motorcycle shot, because it was hard to find a bathing suit with a top that fit properly.

For this picture, the background was a sheet of blue seamless paper. We fired a strobe head, diffused through a sheet of vellum, right at the bottom of the paper to give it a little gradation. The main light for the picture was a strobe in a large umbrella in front of Penny. There was a third strobe behind her—a backlight that highlighted the raindrops and made them stand out. Penny was standing in my little plastic pool, and the "rain" was provided by an assistant standing on a ladder with a watering can of warm water. Don't pour cold water on models!

This model with the gloves—Nancy Young—is the same girl in the photographs taken against the "period" backdrop in Chapter 2, and in photographs in which she is looking over Glenn's shoulder in Chapter 6. She is a great model who can have many completely different looks in many types of pictures.

Nancy needed a "body shot" for her portfolio—a photograph that shows her figure, as well as her face. She wanted something very contemporary, almost "punk," because her portfolio was full of carefully costumed, "period" pictures. So we decided to get together with Rona Krauss, a hair-and-makeup artist with whom I often work, to do a test. Rona has a wild sense of fashion, and this shot is the result.

I already had the gloves in the studio. We bought them for another shooting—a book cover—but never used them. So we decided to take a picture of Nancy wearing very little except these great black gloves.

This photo on the right is probably the only picture in this book (not counting the grainy ones) that was not taken on Kodachrome. I used Fuji slide film, ISO 50. I had heard that type of film had a warmer, redder tint to it than Kodachrome, and I wanted to try it myself. Nancy's skin was so pale and white—it was the middle of winter—that I decided this test offered the perfect opportunity. The lighting was simple—one large umbrella in front of Nancy, with a hairlight over her.

Rona also did the hair and makeup for the other picture shown here—the picture of Harvey (her professional modeling name). I call it the "vampire look"—because of the yellow lipstick! But I must admit it worked, and the result is a very dramatic and eye-catching shot. It also probably won't be dated too soon.

The main lighting was provided by a group of four strobe heads firing through a large sheet of white parachute silk in front of Harvey and off to my left. This technique I often use on location (although this picture was taken in our studio). It is easily transportable, quickly set up, and provides a beautiful, soft light that flows around the subject. There was also a hairlight above Harvey.

The background was a large canvas backdrop painted by Charles Broderson. My assistant, Joe, walked through the set with a fog machine between photographs. This fog helped to hide the seam where the backdrop butted against the brown paper floor. Harvey's dramatic pose also helped to cover it up.

The point of these pictures, and the reason I show them here—besides the fact that I like them a lot—is to illustrate that you shouldn't always stick to tried-and-true—and often tired—photographic ideas. Sometimes you should break the rules. Work with some ideas simply because you want to. Do something very dramatic. Do something a little wild, or a little shocking. Art directors will notice the pictures and remember them—and you will learn how strong photographs can be.

Men can be photographed with tougher, higher contrast, and more directional lighting than can most women. Sometimes it seems that the tougher the lighting, the better the shot. It gives a "macho" feeling, and helps to emphasize strong, angular features. Things like shadows under the eyes often flatter men, while they would be disaster for a woman.

You can use lights on men from the side—something I rarely do with women—and use lights that fall off fast, like a striplight or focused spotlight. Also unlike a setup for women, I often use black flats on the side of the set when I photograph a man in the studio. These help to sculpt (or outline) a strong jaw and straight cheeks, rather than softening them, as white flats tend to do.

Men also don't have to be able to move in the same way as good female models. They can just stand there—as long as they project some presence. It's like looking at Clint Eastwood—he can just stand there, and he doesn't even have to open his mouth. Indeed, sometimes it's best if male models just stand in one place, and the female model, or the photographer, moves around them.

The tighter photograph of a man's face (John's face) shown here is an example of a strong type of directional light that probably wouldn't work for a woman. This picture was taken late one afternoon, when the sun was extremely low, and light was coming in hard from one direction. (You can tell how directional the light was from the way the drops of water pop out, with small highlight reflections.) The picture was taken on a boat in Maine, without any added fill light (as we would have done for a woman), but it makes the guy look great.

The other picture—Chaz playing pool—was a big production. This picture was lit by a large banklight (with one quad head) in front, lights overhead, fill cards, and spotlights—quite a complicated scene.

We rented the Victorian pool table downtown and had it transported to the studio. It took two guys with fancy equipment to move it, and it cost us $900 to rent the table and get it in the studio. Then we had to build the mantle and fireplace, get all the right props, and so on, but it was worth it.

Chaz is wearing my "portable mustache," but originally this wasn't going to be a picture of a man. I got the idea for a test with a pool table from a painting of two girls playing billiards, which I bought in an antiques store. The first night of shooting, we took a picture with two girls that was very similar to the painting. Then, since we had paid so much to rent the table and build the set, we decided it was a good idea to take advantage of it and shoot some video, as well. So we had Chaz come in the next night to work with the girls in the video. He looked so natural around the table that I decided to take some still shots. They were so good, I ran this one in an ad in a creative directory. Now people—art directors—still ask for pictures similar to the one of "the guy playing pool," so it was worth all the hassle and expense.

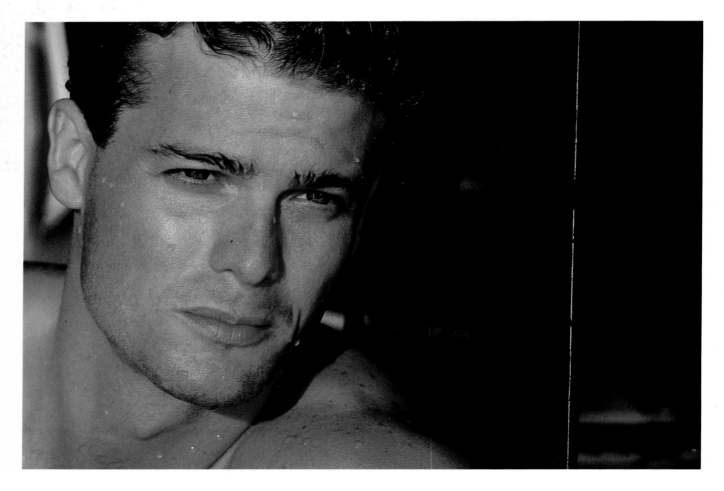

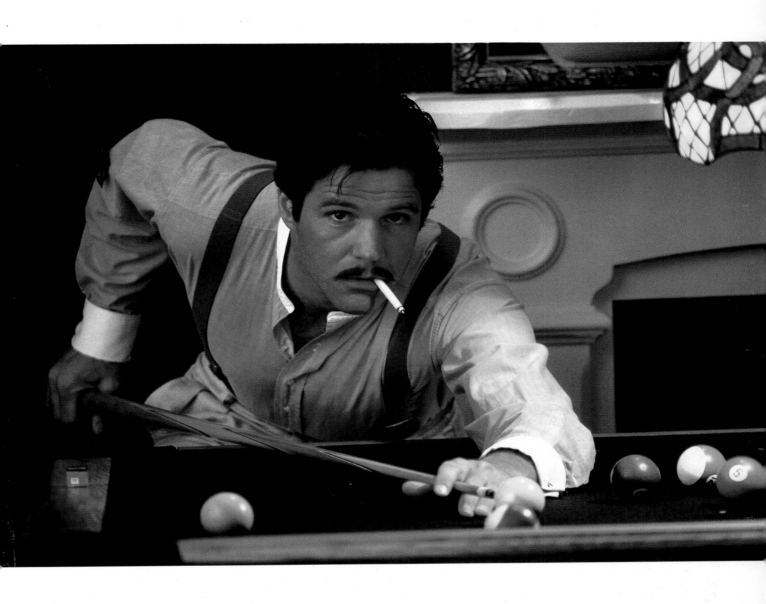

Children are one of my favorite photographic subjects. I enjoy being around kids, they like being with me, and we both usually love the pictures we get.

Children are relatively easy to photograph. They are so cute, so pure and positive, that this feeling comes through in photographs. Most kids enjoy having a fuss made over them, having their hair done, and so on. It makes them feel special, and they love being photographed. They enjoy the "play" aspects of the costumes and props, enjoy acting a certain way, and all the rest. In many ways, photography is like play.

The girl shown here with the flowers and red shirt is my daughter Kendra. I took this picture when she was very young, and I was just starting out. Kendra is 20 now. This is a very simple picture—she's just standing in a field with the sunlight striking her. She had been running and just stopped all of a sudden. It shows how one instant of an expression can make a great picture.

The picture of the little girl with the goose was taken in Tahoe more recently, where I was teaching a workshop. There's a funny story behind this picture. Various professional models had flown in from New York and Los Angeles so the class could photograph them. But this little girl—the daughter of our cook—started following us around, and soon everybody started taking pictures of her. I think we took more photographs of her than of the professional models.

This picture also was taken outdoors, but it was more complicated than it looks. It was a very bright day and the girl was under a movie scrim (a large sheet of netlike material) that we set up to cut down the light. If we hadn't set up the scrim, the light would have been too bright and contrasty for good photographs. We would have had to make a choice between exposing to get detail in the girl's dress (and having the fence come out too dark), and exposing for the fence (and losing the detail in her

dress). Using a scrim provided the solution, and it also was easy to do, because we could attach one side of it to the top of the fence.

The slight glow around the girl and goose was caused by our using a No. 1 soft filter in front of the lens. The slight diffusion added an element of fantasy and interest to the picture. The goose kept waddling away, and we had to keep shooing it back into the frame. Soon after we took this picture, the goose found a break in the surrounding ring of students, photographers, and assistants, and made a mad dash to freedom.

The picture of the little girl with the baby pig was taken recently in our studio. The whole thing started when somebody showed me the pig, and I thought it was really cute. I had no idea how pigs squeal, and how crazy it would be to have it running around the studio. I have included the picture here because I love it, and because it works well with the shot of the girl and goose.

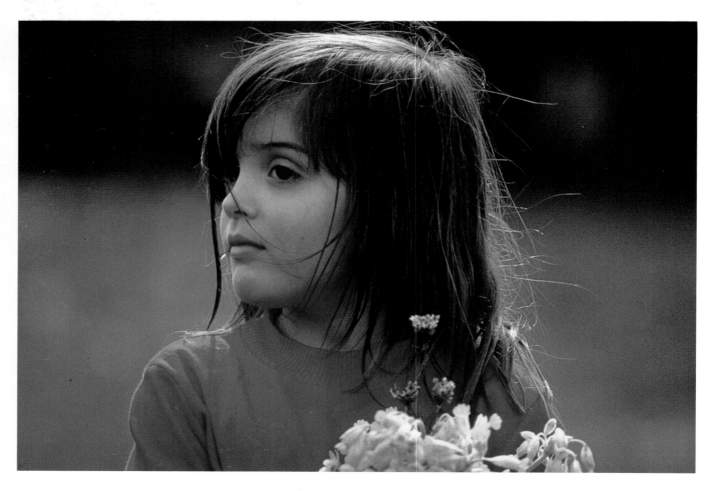

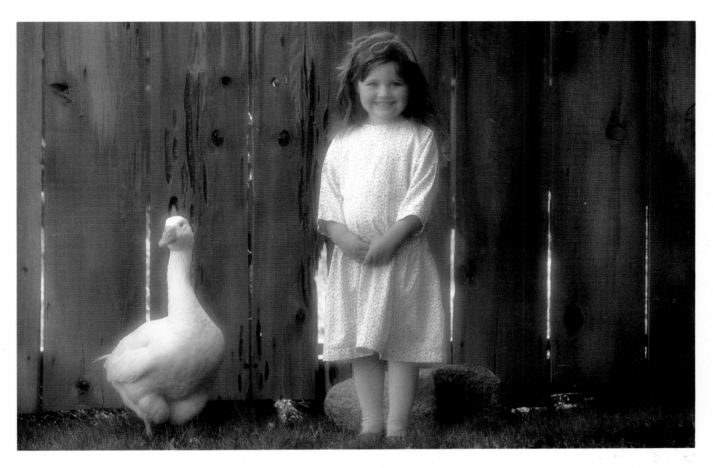

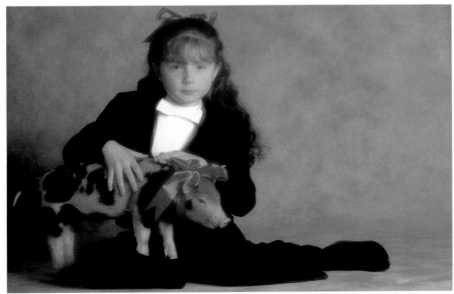

don't really do "fashion" photography, as many people mistakenly think. I photograph people for an area of photography known as "commercial illustration." There is a big difference between "illustration" and "fashion" photography, which commonly require very different types of models. Illustration photography requires models who are handsome, beautiful, or interesting—but more "real" and accessible, and less extreme than models used for high-fashion photography.

The girl shown on the right is a good example of a certain type of model used for commercial illustration. She has long, beautiful hair, but her haircut is more "classic" than "trendy." She also looks great without any makeup. She looks lovely and very real, like someone you might know.

These pictures were taken as a test, but one of them sold for the cover of a brochure recently. The art director called and said he wanted to see pictures of pure, healthy, real-looking women dressed in white. I had lots of those, and he picked one from this shooting.

The picture of the guy holding the drink was taken as part of an advertising assignment for Campari. He looks good, but the drink looks even better. The drink had to look good, since it was the real subject of the photograph. The model is just there to hold the glass and show off the drink.

The lighting for this picture was quite complicated, even though it was taken outdoors. The bright sun was behind the model, so my two assistants, Glenn and Bob, held large white reflector cards to

bounce light back onto his face. We carefully cut a small silver reflector card and pasted it on the back of the glass. This made the drink brighter and the liquid shine more. To give it even more "pop," David used another bright silver reflector to focus a spot of light from the front right onto the glass. All of us—David, Glenn, Bob, and myself—easily could see the effect of each of the reflectors and control the amount of light by making slight changes in their angles.

The result is a very controlled, bright, and commercial picture—a handsome, healthy-looking man holding an appetizing and obvious drink. He looks great, but at the same time, not too amazing to be real. He looks like someone you might know very well.

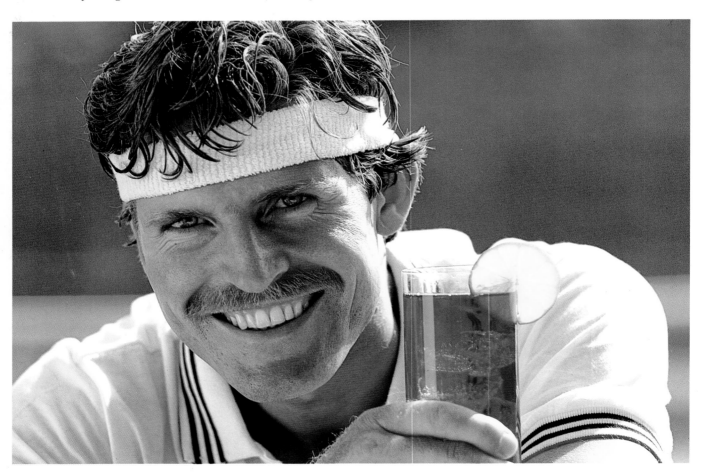

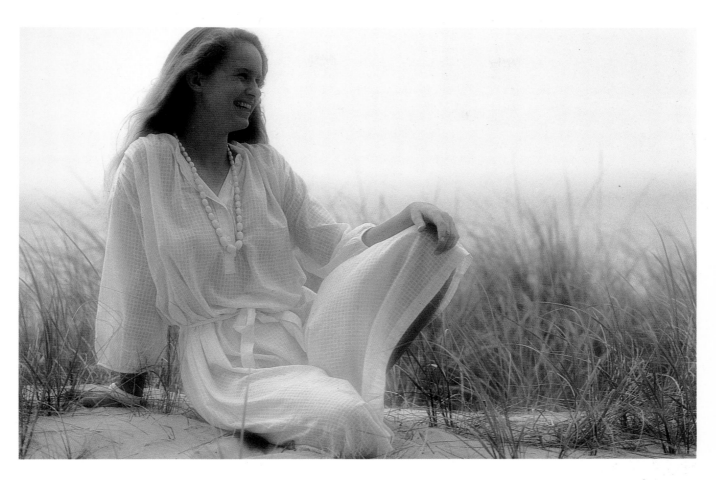

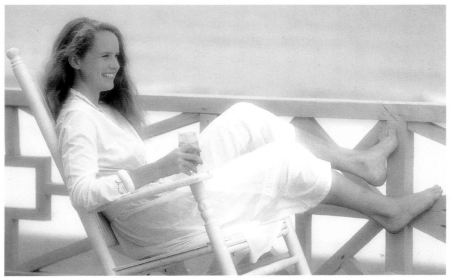

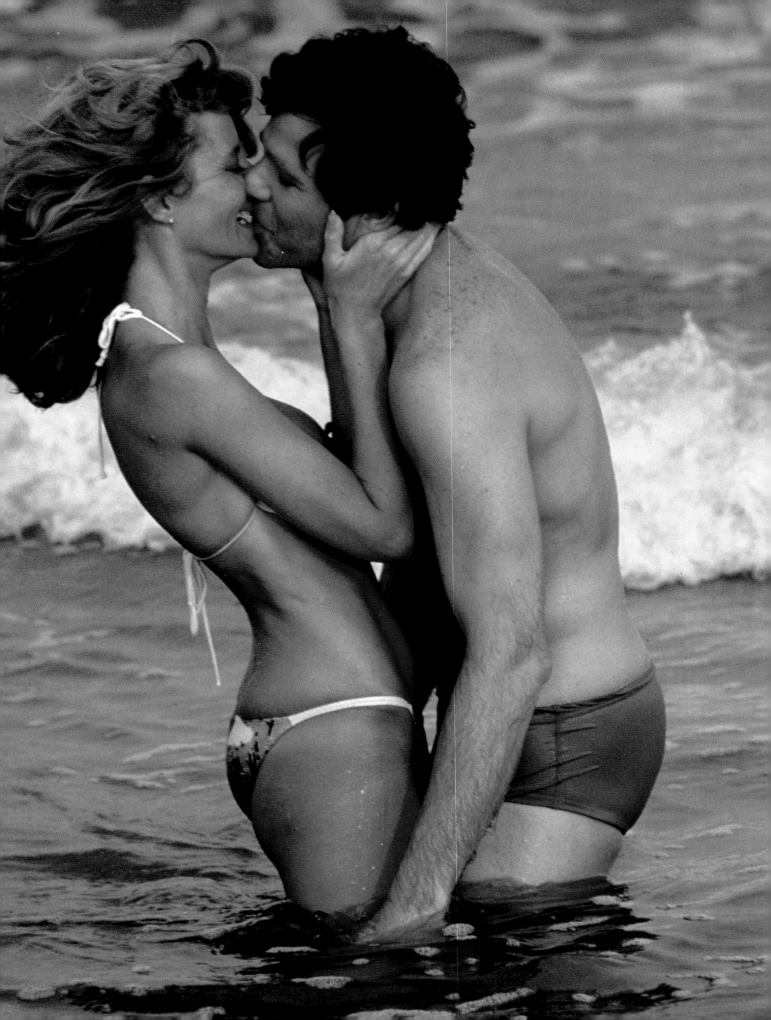

Chapter 4

PHOTOGRAPHING COUPLES

I love photographing couples. You can do much more with two people than one. The models work off one another, and you have the emotional element of human interaction—the whole range of rapport and relationships—to play with and capture in your photographs.

When photographing a couple, you are working with two different people. If one of them is down, or is stiff and cold, the other can often help loosen up, inspire or even force the one who is off to interact. It's incredible when this happens. You just have to stand back and let them do their thing.

There are two distinctly different ways in which couples can be photographed. The first way is with both people interacting and relating to each other. The second way is with both people used as objects, static shapes, rather than as emotional human beings.

I think the best pictures of couples are those that show human interaction. In those pictures, the models are alive, and something is going on between them. It can be a good relationship—happy, healthy, even sexy—or it can be more somber, a crisis, a moment of melancholy, even the angry dissolution of a relationship. That interaction is obvious in the models' faces and bodies. In those pictures, the relationship is what you are focusing on, what you are photographing, and you have to concentrate on the interaction to capture the often fleeting expressions that tell the story.

But sometimes there is no real interaction between the models. In this situation, you only can photograph them as shapes, almost as objects. You have to think of poses that don't require interaction or expressions. You must use the models' bodies and positions as design devices, more than anything else. You are concentrating on form, rather than emotion.

These types of pictures are not as good as those that illustrate some interaction between the models. But when the environment isn't right, or the models aren't relating, they are the pictures you must take. Faced with that reality, you have to be resourceful and do your best.

These opening pictures show the first type of photograph—a couple interacting. These are from a test shooting with Chaz and Cheryl described on the next two pages. Other photographs in this chapter show variations between the two types of photographs.

W hen great rapport develops between two models, you are foolish not to take advantage of it. That's just what happened here. Chaz and Cheryl were into kissing that day. They kissed all day long, which was fine by me!

Chaz and Cheryl Bianci were having a great time, so I stayed away from them. They even may have forgotten I was taking pictures. They were doing so well, there was no need for direction. All I had to do was flow with the situation and keep taking pictures.

These pictures were taken at Chaz's brother's house on the New Jersey shore near Atlantic City. Chaz said he wanted to do another test, and had a beach house near "the City." Some joke—we got in the car one Saturday morning and drove for hours. But we all had a great time and it was worth it.

We laid out all the different clothes people had brought, and just picked out what we liked. Then we went outside and took pictures of Chaz and Cheryl kissing. Kissing on the porch. Kissing on the beach. Kissing in the water. It was great. I moved around the two of them, changing positions and changing lenses—from the 105mm to the 180mm—coming in tighter and then moving away, trying to capture what was going on.

It's magic when you can photograph a couple like this—when two models develop rapport and really interact. It makes for the best kinds of couple pictures.

The pictures all were taken outside that day, under available sunlight, with reflectors for fill light when needed.

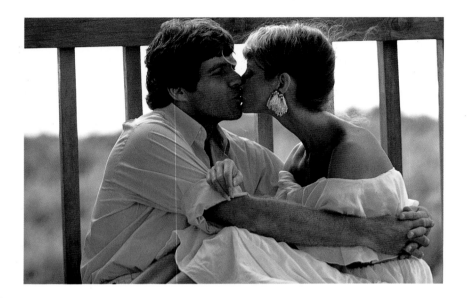

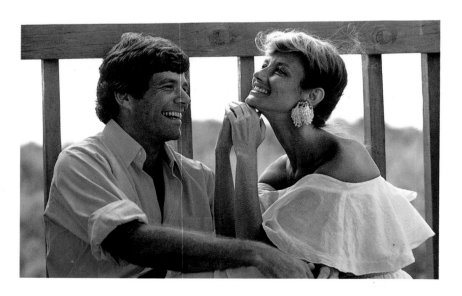

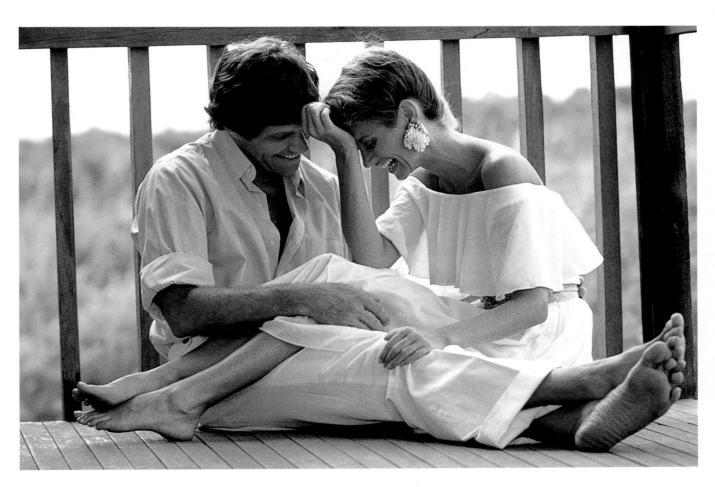

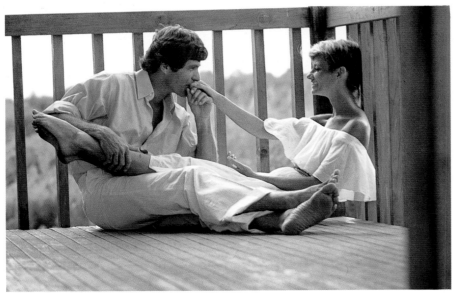

We took these two pictures on the same day, with the same models. In the morning we took the old-fashioned, "period" picture in front of these little Federalist houses in downtown New York. In the afternoon, we went uptown and took the more glamorous picture in front of a small building off Madison Avenue.

The female model was my friend Winifred from our agency. The guy was Jim, from Click Agency. He was new and inexperienced.

In the morning, his self-conscious posing worked well for the humorous, car- icaturelike pictures we had in mind. But I knew stiffness would never work for the pictures that afternoon. So I talked to Winifred. I asked her to help make Jim loosen up. She knew just what to do, and was great. She joked around, teased him, grabbed him. He quickly forgot we were taking pictures, and concentrated on her. He started to interact, and move. In fact, he became quite good and started doing his own thing.

Certain models can do that. They can supply a spark of energy that pulls along the other models. Even in a large group, one or two good models can make the whole group come alive. They can provide the focus, and stimulate everyone else.

In the picture on the right, Winifred and Jim are relating. In the picture below, they are objects.

Stephanie Weisman was the stylist that day, and she was great. She brought the perfect props and clothing, and really put the pictures together. Joe was my assistant. About 30 students from the International Center of Photography also took pictures of Winifred and Jim. That may have been why Jim was stiff at first. It isn't easy looking into 30 lenses at once, especially when you are so new.

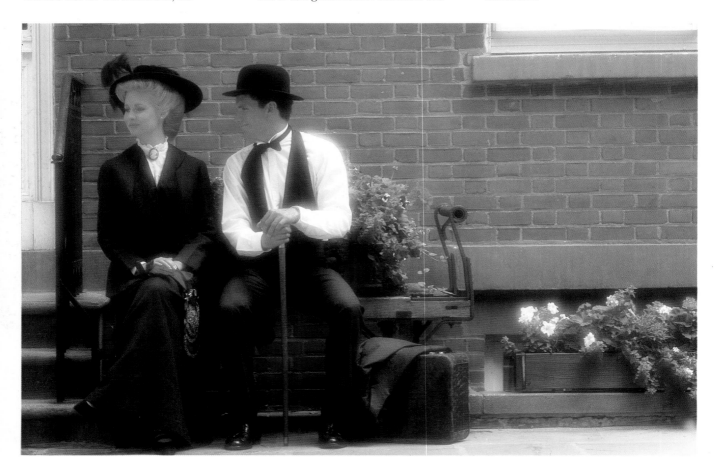

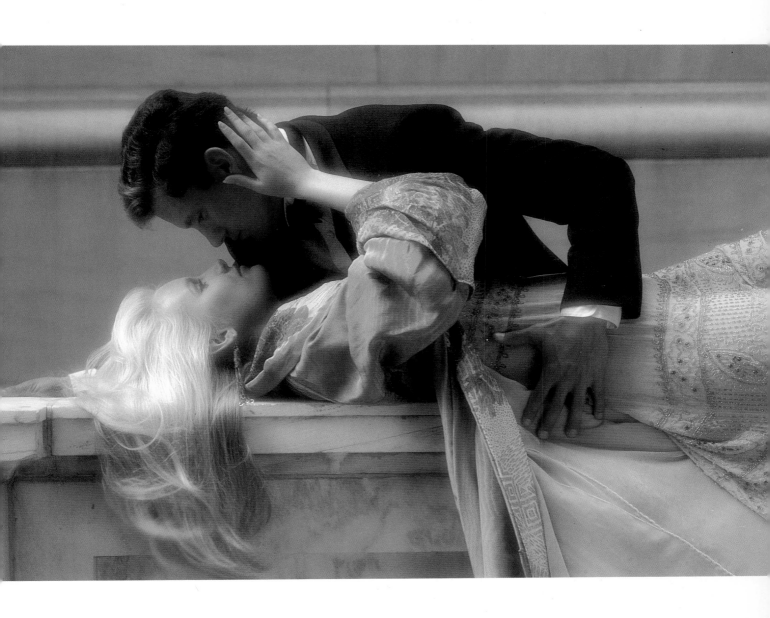

This picture was taken in Maine, and is quite different from other pictures in this chapter. Most obviously, it's grainy. Less obviously, it shows a couple used as an accent in a larger picture, rather than as the primary subject. It shows models used as part of an overall mood.

I was teaching a course at the Maine Photographic Workshop. The day was incredibly foggy, and the whole class assumed we wouldn't go out to shoot. But I walked in and announced we all were going over to the seashore. Because it was so foggy, it was a perfect day to shoot.

We had a ball, and it proved the point. You don't need sunshine or bright light to take good pictures. You just have to be able to get a light reading. Indeed, the best pictures can be taken on the worst days.

Maija and John were the models. We brought along all kinds of slickers, raincoats, and umbrellas. They were great props, but the simple white clothes really saved the shot. They were bright, but didn't clash with the moody atmosphere of the fog and crashing sea, as did the yellow slickers and red umbrellas. Notice that the models are not wearing shoes. Since we didn't have any shoes that looked good with white clothes, we decided to try the shot without shoes, and it worked.

It was an incredible place, and an incredible day, like something from a movie (maybe *The French Lieutenant's Woman*). Surf was pounding on rocks with a primordial sound, and fog often made it hard to see farther than a few feet.

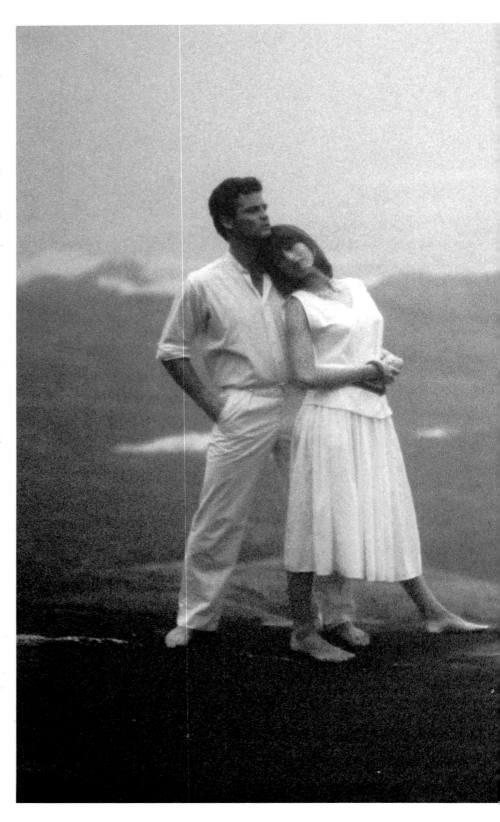

These two pictures fall into the second type of couple photograph—ones in which the models are important as shapes and forms, rather than as people interacting and responding to each other.

The picture below—the threesome on the blue raft—doesn't show a couple, but illustrates the point well. It shows static shapes, and includes more than one person.

This picture was taken on Fire Island, near New York City. The location was a beach house owned by a friend of the male model. There were these incredible blue rafts by the pool. The minute I saw them, I knew we had to use them for a picture.

Luckily, the house had a balcony outside one of the second-floor bedrooms. When I stood on it and leaned over the edge, I was at a very unusual angle, and could shoot practically straight down.

The picture was taken by available sunlight, with two large sheets of white foam-core propped up under the balcony to add fill light from the shadow side of the scene. The film was Kodachrome 25, and the lens was a 105mm.

You can see the models aren't relating in this picture. Even though the guy has his hands on both girls, they are just lying there stiffly. The two girls were sisters, and I took a number of shots with just the two of them. Those pictures showed interaction. One shot—the two girls frolicking in the surf—brought me a large assignment for a Canadian cigarette company, Belvedere. (See the picture in Chapter 9, "Handling Professional Assignments.")

The second picture—the couple on the white boat—is another example of a photograph in which people are largely shapes. It was another test shot. However, you can see an obvious product—the drinks—in the picture. I often try to work some product into my test shots. The fact that this picture includes drinks might catch the eye of an art director for a liquor account. It is obvious how this idea could be applied to a liquor advertisement.

There is a funny and informative story behind this picture. We went to the marina planning to take pictures on a lovely wooden boat owned by a friend of the male model. But the day was very cloudy, and it was raining much of the time. The wooden boat was beautiful in the sunshine, but looked horrible in the rain. The dark, teak deck looked like mud under the dark sky, and blended into almost black water.

Suddenly, this white fiberglass sailboat pulled into the marina. I ran over and asked the guy who owned it if we could use his boat for some pictures. Before he had a chance to say yes, my assistants had pulled out paper towels and glass cleaner, and were busy polishing and working over his deck.

The white boat saved me, the picture, and the shooting. The white deck and shiny rails contrasted with the dark water. Even under a cloudy sky, they looked bright and interesting. The boat had a great, graphic shape, and the yellow lifesaver was already there. We only had to add the people, drinks, and reddish fan. And we had to keep mopping rainwater up off the deck!

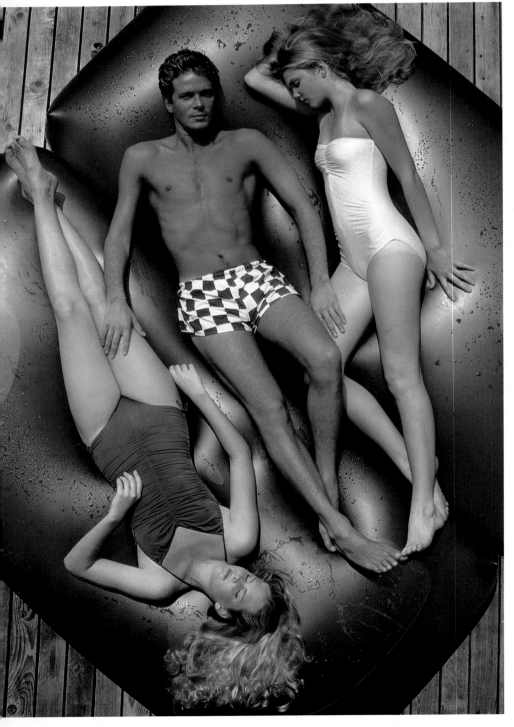

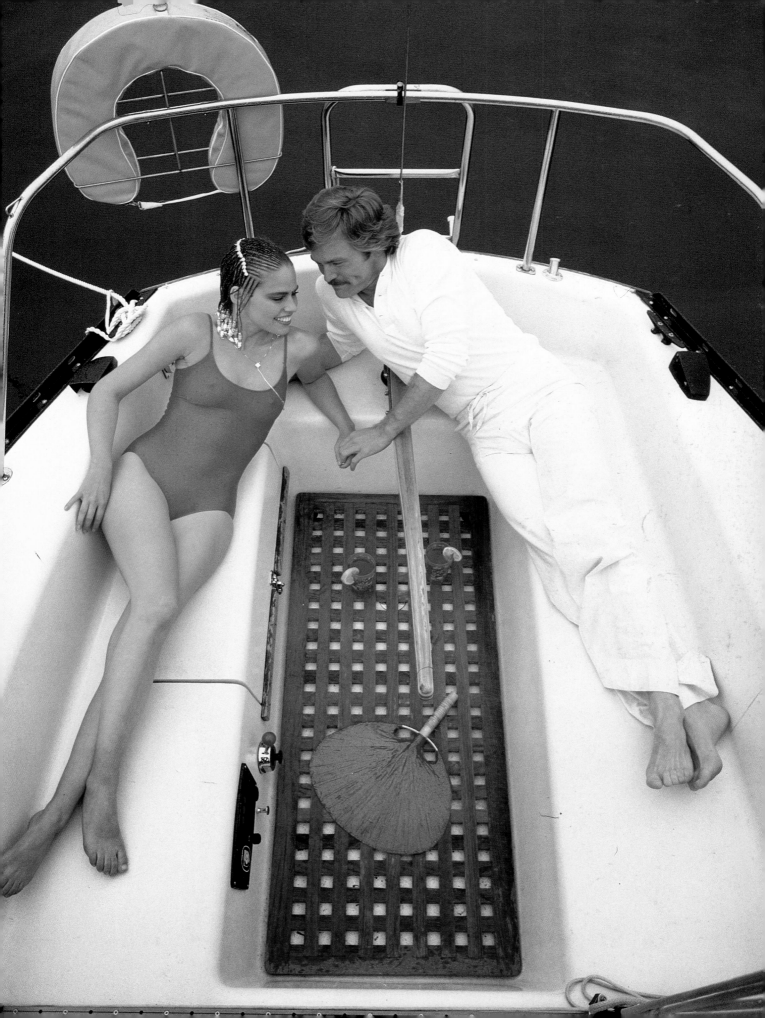

Michael Dezer, the man who once owned the building our studio is in, has a collection of antique cars. He asked me to take pictures of them, and invited me to come out anytime. So one beautiful Sunday I took him up on his offer and drove to Teaneck, New Jersey. I took along two models—Anne Cowie and Dave—no assistant, and lots of antique clothes.

We picked out a lovely red convertible, cleaned it up, and drove to a small park nearby. We got great pictures, but unfortunately for Michael, the best ones didn't really show much of his cars. Somehow, the tighter framing worked best.

At one point during the shooting, Dave told Anne a joke, and she laughed. That's what I like best about this picture—Anne's real laughter. It is the key to the photograph. It gives the idea that models are really responding to each other, and enjoying themselves.

There's a strange thing about this picture. The car is parked, standing still, but somehow it looks as if it were moving, as if Anne and Dave actually were driving. Maybe that's because the background is a little blurry. Maybe it's because Dave is holding his hands on the steering wheel as if he were driving, or because Anne looks like she is trying to hold her hat on.

Perhaps it's the combination. I'm not sure why, but I like the way it looks as if Anne and Dave were driving and not just talking in a parked car.

Kodak later bought one of the pictures from this shooting, one similar to this, but without Anne laughing. It was used inside a brochure for Kodachrome 64 Professional Film, the same brochure that has the picture of Angie with the horn on the cover.

You can tell I used a diffusion filter—a Nikon No. 1—by the flaring highlights. The sun was coming from behind the models, so we reflected a good deal of fill light from the front. The film was Kodachrome 64 Professional, of course.

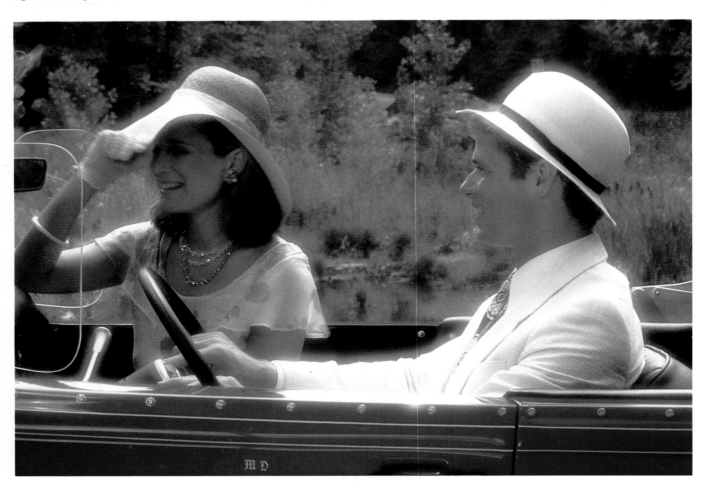

This picture was taken in Asheville, North Carolina, while I was teaching a workshop. It has a great feeling of intimacy, and I love how the models flow around each other. Obviously, they are interacting, even though thirty other people were in the room.

The light came from modeling lamps on the strobes and windows in the room. We were going to use strobes to light the picture, but the scene looked so good under the modeling lamps, I decided to try it with only them for illumination. We had to use very slow shutter speeds, and large apertures with little depth of field, but there was no reason not to—nobody was jumping around, and the softness worked perfectly for the romantic feeling we wanted. The film was Kodachrome 25 and, with the slow shutter speeds and limited depth of field, it was unnecessary to use a diffusion filter.

The models were Bryon and Molly (from Asheville). The couch was already in the house. The satin pillow and girl's nightgown were bought in a local store. The guy was wearing his own jeans, and didn't require much styling, other than combing his hair. The girl's makeup took a little longer, and was done by Jody Pollutro.

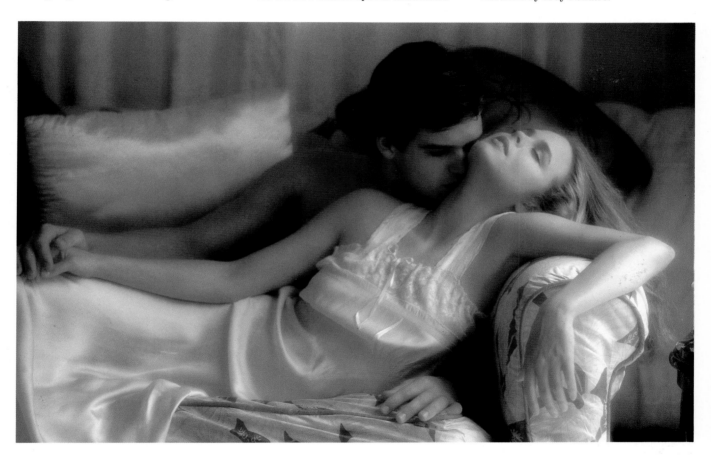

This picture of Ken Miller and Lynn Jefferson was taken outside, late in the day, on Long Island. It was taken on the same day as a picture of Lynn bundled in a fur coat, which I used in an advertisement in *The Creative Black Book*.

I love Lynn's face. She looks more like a movie star than a fashion or still-photography model. She has a very different look, both real and glamorous at the same time.

Ken's looks complement and work perfectly with Lynn's. He is handsome, but in the way an actor is handsome. In that leather raincoat, he looks like a chic spy. He's not a "pretty boy," but can project an attitude, and that was what I needed. (He is in the swing test on pages 26 and 27.)

This is a very simple, straight picture. The models are looking right at the camera. The background is simple, a blue sky. It looks more like a portrait than a constructed advertising photograph, yet it could be used to promote many products. It could advertise the winter season at some beach resort, or be an ad for men's cologne.

It could even advertise life insurance or financial planning.

It is a simple picture, but it includes interaction. It shows two models relating to each other, working as a team to produce a unified picture. It shows how the simplest, most direct approach can result in the best picture. You don't have to set up elaborate situations always to produce powerful, commercial photographs.

This was taken right at sunset with the sun right in the model's faces. As I have said before, this is the best light.

Nicky Higgins (a model and friend) has great legs, hands, and hair. She also has a wonderful face and personality, but she is most often hired as a model for legs, hands, or hair.

Nicky asked me to take pictures of her that stressed these features and showed them to their best advantage. We decided to shoot in the studio, and set up a striking picture in which each of her three attributes would be highlighted, and each one could be studied separately.

The background was one of my favorites—a piece of black velvet—and the set was very small, probably less than three feet deep and four feet wide. The table was crammed up against the velvet backdrop. There's no need to worry about keeping spill light off velvet, which just sucks up light and always looks black.

I wanted to use a glass, or mirrored, table but no one would lend or rent one. They were worried we would break it by moving it around. So we used a table I owned, a white wooden one, and covered it with pieces of carefully cut, mirrorlike plastic. That worked beautifully. It contrasted well with the black background, and probably was cheaper than a rented table.

The clothes and accessories were already in the studio, left over from other tests and jobs. I had a male model, Don Bowron, come on the same evening. The two kids were wonderful. They had a great time, got along well, and worked off each other perfectly. We took lots of pictures that night—the color lab must have loved it— and got all sorts of different photographs. Some were funny, some slightly sexy, and others were very graphic.

Notice how the three things Nicky wanted to show are individually highlighted. Her legs are posed to look their best. Her hands are shown both in profile, with the fingers spread, and straight on, with the fingers together. Her hair looks lovely, the way it is spread out and covers one leg of the table. It draws your eye right to it, causing you to ponder whether the table is breaking the rules of gravity.

The lighting was quite simple—one large banklight slightly above and in front of the models, and a hairlight (a silver umbrella) pulled down close above them. You can see the hairlight on Don's hair, but without it, his hair would have blended right into the background. His head would have seemed like the shape of his paler face.

I love this picture so much that it almost was used for the cover of this book.

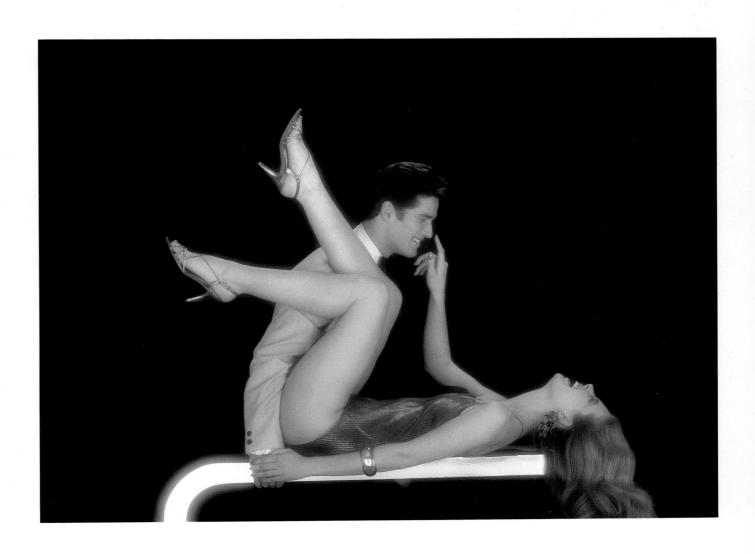

Chapter 5

THE SPECIAL AREA OF
BEAUTY

Beauty photography is a specialty area inside the larger areas of fashion or advertising photography. A number of photographers have built whole careers on their talents in the area of beauty photography, and they do almost only this type of work.

I personally love beauty photography. It is work I enjoy, and it requires a certain outlook and attitude that goes along with my feelings about life. In fact, when people ask me what type of pictures I take, I often describe them as "people photographs with a beauty feeling."

Most beauty photographs are tight close-ups on immaculately madeup faces of extremely beautiful women. The term "beauty photography" probably comes from clients that often use this type of photograph—companies selling skin products and cosmetics that promise to make women beautiful. However, many other types of companies also use beauty photographs in advertisements and publications.

Beauty photographs have a particular feeling and look. Usually they are super-clean, with a glamorous or healthy atmosphere. Even the smallest elements—strands of hair—are carefully styled and perfectly in place. Good beauty photography requires an almost fanatical attention to detail, and a stylistic affinity for fantasy and high glamour.

Beauty photography is very different from fashion photography (although many fashion photographers do both). In fashion photography, the clothes are the subject, even when the picture only shows the feeling or pervading mood a client wishes to associate with them. In beauty photography, the model's face, and especially her makeup, are the subjects. Clothes are background elements, props used to frame the face or play off the colors of cosmetics.

Much beauty photography is "high-key," composed of predominantly light tones. But as you will see in this chapter, it is possible to take other kinds of beauty photographs, especially if the model's face is so strong that it stands out from a darker background.

Most beauty photography is softly and evenly lit to better show every tiny detail and to eliminate most shadows. But again, there are exceptions to this rule. Certain women (very few) have faces so striking and fantastic, they can handle harsher, stronger light. Indeed, some strong faces even work better with strong, directional light.

Absolutely immaculate skin is crucial for beauty photography. I always try to use models with good skin in my photographs, but for a beauty photograph, the model's skin must really be fabulous—bright, smooth, and unblemished. After all, the subject of most beauty photographs is the skin, or at least cosmetics on the skin.

The picture here of Susan with the globe earrings is a good example of a beauty photograph that breaks a number of rules. It shows you should be ready to break the rules, and not allow yourself to be trapped by a formula just because someone recites it with authority. You always should do what works best for a particular person, what is needed to produce the picture in mind.

Susan is only 16. She has a knockout face and the most beautiful skin. I rarely take a beauty photograph without using a diffusion filter, but Susan's face was so good and the makeup done so well, I knew the pic-

ture would look great dead sharp. I used a larger aperture ($f/4$) than I normally would on my 105mm lens, because I wanted a limited depth of field. I focused right on her eyebrows, and let much of her hair and neck go out of focus. You can see that the earrings look quite fuzzy.

Susan was lit by a large bank of strobe heads almost directly in front of her, but placed higher than her head. There was a shiny silver reflector card right underneath the bottom frame of the photograph. This card reflected bright light into the picture from below, lightening the underside of her dark hair, adding dazzle to the earrings and

sequined top, and causing her lovely face to stand out from the darker environment.

You can see the two light sources reflected in the model's eyes. Reflections like these are called "catchlights." You can see them in many beauty photographs and portraits, and can use them to figure exactly how the lighting was arranged. You can see the telltale shape of a large bank-light or flat, and the shape of an umbrella. Many beauty photographers are very concerned with concentrating on catchlights. They pride themselves on being able to produce reflections of a certain kind, which they consider to be signatures of their work.

USING MIXED LIGHT SOURCES

This technically is not a beauty photograph, although it has the feeling of one and it was done for a beauty client, Pert Shampoo.

It is actually a single frame from a "photomatic." A photomatic is a test television commercial, shot as single frames by a photographer. The frames are shown in a rapid series. Photomatics are used by advertising agencies and clients to get an idea of how a proposed commercial will look, or to test a commercial by showing them to focus groups of consumers. Photomatics are much cheaper than full-scale television productions, although they still cost a good deal and involve a lot of hard work. Many professional photographers make a lot of money from shooting photomatics. Once a photomatic is approved, it is used as a guide for shooting an actual commercial.

The first frame of this particular photomatic was a shot of the setting sun. The camera zoomed in on the sun, then pulled back to show this picture. Obviously, the idea was that the sun was in the model's hair.

Getting this particular glow effect in the model's hair was not easy, especially because the client wanted a lot of movement and animation, and let me tell you, that model was really moving. Finding her wasn't easy, but she was great. It took a lot of casting to find the right model.

The background was a huge sheet of black velvet, at least 20 feet wide and 10 feet high. The main lighting came from a large umbrella suspended on a boom, placed in front and slightly to the left of the model. The light from that umbrella froze her frantic motion.

We rented a hurricane fan to blow her hair, and used two bright tungsten spotlights to get the orange glow, as well as the slight blur for a feeling of motion. One tungsten spot was placed behind the model, and another in front. Both were trained on her hair, although some spillover light fell on her face. We started by using only one spot—behind the model—but it alone didn't provide enough light, so we added the second spot in front.

We used a slow shutter speed—about 1/2 sec.—and set the power of the strobe to the same exposure indicated by reading the tungsten light alone. This is called "balancing" the two light sources. If the proper exposure by tungsten light alone is f/5.6 (the aperture setting I use most often) at 1/2 sec., then the strobe also is set to provide proper exposure at f/5.6.

Although the camera's shutter stays open for a longer period of time, the strobe only fires for a brief duration (probably less than 1/1000 sec.) of the exposure. The result of the combination is that the warm tungsten light registers as a blur on the film, and then the cooler, faster light of the strobe comes in and freezes one instant of the action.

I like the effects of combining strobe and tungsten lights. I especially like it when the warmer tungsten spot comes in and highlights one little area, or falls in a small pool of light, somewhere in the frame. There are a number of ways to combine different types of light sources. (For further discussion, see Chapter 8 on "Special Photographic Techniques.")

BEAUTY WITH A SPORTY TWIST

This photograph is another of my many tests, a sample I shot because I liked the idea. When I saw the final picture, I loved it, and decided to use it for one of our ads in a directory. It instantly generated calls from art directors on makeup accounts, and has brought me a lot of work.

The picture began with the hat. One year, returning from the Maine Photographic Workshop, we stopped at L.L. Bean, the famous outdoor and direct-mail clothing store in Freeport, Maine. I fell in love with this real French rabbit-fur hat and bought it. As with many of my best props, I picked it up with the vague idea that I might use it someday, and it led to a terrific photograph.

When I showed the hat to the makeup woman who had come with us and said I thought I could do something with it, she replied, "When you're ready to do something with it, give me a call." So, when I got back to New York, I kept my eyes open for a girl with really good skin. We already had the fake snow in the studio from another job, and one of my assistants owned the perfect scarf. The whole thing just fell together, piece by piece—an interesting furry hat, a good makeup job, a girl with phenomenal skin, and fake snow that wouldn't melt.

The lighting was simple—just one large banklight with one quad (four-tube) head in front and a bit above the model, and white fill cards lying flat on a table in front. The result was a classic beauty photograph, but with an unusual sporty, skiing twist.

This model, Barbara Blackburn, is a good friend. We've worked together on cosmetic advertisements. She can have many different looks, but it seems she always is made up too heavily in photographs. So one day, we decided to take a photograph with a very soft and natural look, one that showed the way she looks in real life.

On the morning of the shooting, I borrowed the hat and antique gown from another friend who runs a costume rental business. My assistant hung up a simple, unpainted canvas background.

When Barbara arrived, we went to work. Together we did her makeup and fixed her hair. We kept the makeup soft and light, her hair loose and natural. The minute Barbara saw the dress, she knew what I had in mind.

We took lots of pictures that day, and worked with the dress and background. We took shots of Barbara looking healthy and happy, sad or serious, fiddling with the bodice or staring straight at the camera. We shot all the possible variations.

This picture I particularly like. Barbara has a wonderful profile, and the angle of her head perfectly fits the mood of her expression. The picture is diffused, obviously, and the soft quality reinforces the feeling of innocence and fantasy. The pictures we took were all diffused with a No. 1 filter. The softness seemed to fit the romantic, fantasy feeling we were seeking.

The main light source was a single strobe head diffused through an umbrella. This strobe was off to my right, in front and slightly to the side of Barbara. A second strobe head, suspended on a boom and reflecting from a silver umbrella, brightened the hat and acted as a hairlight.

The lens was a 135mm, set at $f/5.6$. Whenever possible, I set my lens for $f/5.6$, and adjust the intensity of the lighting to that exposure. Then during shooting, I bracket 1/2 stop each side of $f/5.6$ with the lens. All three exposures are usable. Choosing is simply a matter of whether you like the slightly darker or lighter chrome. In this case, the slightly lighter exposure seemed best for pastel colors and soft makeup.

This very direct beauty photograph was taken with a "striplight." A striplight is a type of electronic strobe that has a long, narrow bulb mounted in a long, narrow reflector. Striplights are most often used for still-life photographs of shiny objects when the photographer wants to produce a particularly narrow highlight reflection. They are almost never used for beauty photographs, or for photographing people, although I sometimes use a striplight to photograph a particularly rugged man for a very hard, macho look.

The light from a striplight is highly directional, and falls off very fast. I was just learning about striplights when this model, Victoria Tucker, came to see me for some test shots. She had just started with the Zoli agency and was a real beauty, with lots of personality in her features.

Victoria's face was so strong, I decided to try out the striplight and felt her face could take it. Those bright eyes, dark eyelashes, and prominent cheekbones begged for something dramatic, for light that would model her bones and bring out their structure.

I mounted the striplight almost dead center in front of her, which is not how you're supposed to use a striplight. I mounted it vertically, and tilted slightly up, so it would catch her hair, as well as face. We used a dark background, and chose a dark dress and necklace to go with her gorgeous dark hair. The only bright element, other than her eyes, was a pair of cut-glass earrings I had in the studio. They are the same earrings you see in the photograph on page 72.

The result is dramatic and powerful. The vertical column of light fell off right after it touched her face. It barely highlighted the front of her hair, and didn't even touch her shoulders or the background. It caused shadows that strengthened her already strong cheekbones, and highlighted her aquiline nose.

I've rarely had the chance to use a striplight on a beauty job, and rarely have run into a woman with a face that could handle it. But this picture proves that soft, flat light isn't the only kind that works for beauty photographs. It reinforces a point I've made: Don't be trapped by formulas and rules. Instead, look at the face in front of you—really look at it—and then consider what type of lighting to use.

This picture is strange and I'm not sure why I like it. Maybe it's the colors of the earrings. Maybe it's the angle of the model's head, or the way her hair seems to blow off the right side of the frame. There is something going on here, something about the model's expression and attitude, which makes the photograph work.

This picture is a very good example of my favorite lighting, which I use often for beauty photography. It is a simple setup that I learned from another photographer, Jerry Abromowitz, when I took a course from him early in my career at The New School in New York City. Every week, Jerry showed us a new lighting setup, and I'd run home after class and try it on my own. This is one arrangement that I've used endlessly.

The lights are behind the model. Two naked strobe heads, without umbrellas, but with small reflectors, are pointed straight at her back, and one is slightly to each side. Directly in front of the model are two large white sheets of foamcore with a small space between them. I shoot through that small slit with a relatively long lens, a 135mm or 180mm.

The strobes blast the background, and their light bounces back onto the model's face from the foamcore. That reflected light is the softest, most even light you can imagine. It just flows over faces, yet the overall effect is very snappy. The brightness behind the model outlines her shoulders and highlights her hair. When you get it right, the backlight even comes onto the cheeks, brightening and defining them.

If you want even flatter light on the face, add another white reflector horizontally under the model's chin. This bounces light up from underneath that fills in shadows under the chin, nose, and eyebrows. For a darker background, but the same even effect on the face, bounce the lights off the foamcore, but place them parallel to (or slightly in front of) the model.

One benefit of this lighting setup is that it produces almost no reflections in the model's eyes. Every detail is visible, and the eyes are clean, although they may not have the sparkle that catchlights provide.

One final factor in this photograph is worth mentioning—the model's eyebrows. They are very dark and strong. Normally, I don't like heavy eyebrows, but for some reason, they are interesting without being overpowering. It may have to do with the angle of her head, or her expression.

The photograph of Candy on the next page is similar to two other pictures in this chapter, but it is also very different. It is similar to the picture of the woman in a fuzzy brown hat because the model is dressed in ski clothes. I love ski clothes, and the whole idea of skiing on a bright, crisp winter's day fits with the clean, healthy look that works so well in beauty photography. But the colors of the woman's clothes and makeup are entirely different. Instead of subtle earth tones, the picture is composed of very bright, well-saturated, primary colors. Indeed, in many ways, the picture is about bright colors, and probably that's why I took it. It would work beautifully for many clients, especially Kodak. Kodak loves bright red, yellow, and blue combined in one image. Kodak actually did buy it (in the same brochure as the horn shot).

This photograph also is similar to the moody picture of the model with the strong eyebrows looking slightly sideways. It is another example of that same lighting technique, my favorite for beauty photographs. It even may be a better example, because the model is looking right at the camera, and you can see this lighting setup causes no bright catchlights, yet still makes the eyes, face, and skin look bright and alive.

To describe this lighting again, two strobe heads (with reflectors, but without umbrellas) are placed slightly behind, slightly above, and one on each side of the model. In front of her are four large sheets of white foamcore at right angles, with a small space between them through which you shoot. The strobes fire toward the camera, but their light reflects smoothly and evenly off the white sheets and back onto the model's

face. (You have to be careful to mount the camera far enough behind the reflectors, so that no light from the strobes hits the lens and causes any glare or flare.)

Here, there was a third piece of foamcore right below the bottom of the frame, almost parallel to the floor. This sheet reflected light up onto the model's face from underneath, helping to eliminate any shadows under the eyes, chin, or nose. There also was a third strobe head placed low behind the model and firing straight at the blue paper background to lighten it up.

In the picture below, you really can see how the strobes from behind the model outline and highlight both sides of her face for a wonderful effect. You also can see how reflected light from the front illuminates every detail, without causing any harsh shadows.

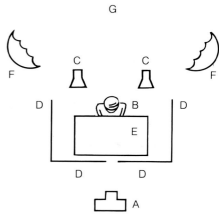

A: Nikon 35mm camera with 135mm lens
B: Subject
C: Calumet strobe heads with 9″ reflector
 aimed into flats
D: 4′ × 8′ white foamcore flats
E: White head-shot table
F: 42″ white umbrellas
G: 9′ Gulf Blue seamless paper

Although the majority of beauty photographs are shot under controlled lighting in studios, it is possible to shoot them outdoors. The best day is bright, but heavily overcast, with soft, even light. A bright, sunny day (unless you're in the shade, or under some sort of diffusion tent) tends to be too harsh, and the light too directional, for most beauty photographs.

This photograph of Beth was taken outdoors on a very cloudy, overcast day in North Carolina. You can see there are hardly any unattractive shadows. This is not only because light from the sky was soft and even, but also because Beth is positioned in a certain way. Her face is almost directly parallel to the light source (the sky) and so her eyebrows and chin aren't causing shadows. This position also shows off the interesting earrings well.

Beth actually was lying on top of a white car. I was standing a few feet away, at the same height as she. The surface of the car cast a little fill light up from below, brightening the undersides of her arms and defining the outline of her hair. Lying on the car also kept Beth from lying in the wet grass, and made it easier to get this angle than if I had to kneel down and peer sideways through my camera.

The picture was taken with a 135mm lens set at about $f/4$. It's diffused through a No. 1 filter. It shows how a diffusion filter refracts light from brighter areas, resulting in an interesting, foggy, flare effect.

BEAUTY OUTDOORS WITH FILL FLASH

This is an editorial photograph for *Glamour* magazine. It was taken on the street in front of my studio, to go with a fashion article about "chokers," one of which is worn around the model's neck. Apparently, neck pieces were "in." The magazine published the picture in black and white, but I covered the assignment in both black and white and color.

This picture shows a technique I hardly ever use—fill flash—but that many people like, or find comes in handy when light is low and they want a picture to look as if it were taken outdoors.

Normally when you use fill flash, you don't want the effect to look obvious or unnatural. What you want is to fill in the shadow areas of the scene, or add illumination to some part, without overpowering the existing light in the rest of the picture. Here the light from the flash (a Norman 200B held close to the camera) is quite bright, but the picture looks realistic. It also shows the model's makeup well.

The technique for using fill flash, and calculating the proper amount of flash, is quite easy, although it's a good idea to practice a bit before blindly using fill flash for a paid assignment. Also, I always check fill-flash exposures with a Polaroid before I start shooting.

The idea is to match up exposure readings from the flash with those from the highlight areas, under the light existing in the scene. For a less obvious effect, you want the flash reading slightly lower than the available light reading.

If you have an electronic flash that allows variable power settings, you can position the flash where you wish (perhaps right next to you) and set it to emit the proper amount of light for its distance from the subject. For a portable flash, without a variable output setting, you should set it to manual and vary the intensity by moving it closer to, or farther away from, your subject. Obviously, moving it closer increases the effect.

BEAUTY UNDER REFLECTED NATURAL LIGHT

This is Nancy. She was standing in the opening of a cave on the Vanderbilt estate near Asheville, North Carolina. The man she's wrapped around is Glenn, a model who is also featured in Chapter 6.

The picture was taken at about 10 AM, and light was not striking inside the cave. But it was very bright outside, and the sun was streaming onto the ground in front of the cave. So I had my assistant, Joe, stand in the sunlight with a bright silver reflector card that bounced the light inside and onto Nancy's face and Glenn's back. It took a little practice, but once Joe found the proper angle for the card, he could focus the reflection exactly where I asked. You really could see Nancy's face light up, or go dark, when he moved the card even slightly.

This effect of reflecting bright sunlight into a scene with a shiny card looks like the effect you get with a flash, but not exactly. The light is more natural and less harsh, and depending on whether you use a gold or silver card, it can be warmer or colder. A lot of professional photographers use this technique, even when they're not taking pictures in dark caves. They have an assistant use a bright card to reflect light into specific areas and highlight certain objects. It's used frequently for photographing jewelry, either in still life or on people.

There's something I really like about this picture, and it has to do with more than the fact that Glenn and Nancy are my good friends. It's not a typical beauty photograph, but has a very dramatic and even sexy quality. Nancy's hands are perfectly placed, and her nails and lipstick really "pop." The angle of the light and her expression are perfect.

This is one of the few situations where I didn't completely cover a shooting, but wish I had. The picture is good, but I should have taken a few frames with a diffusion filter so I could have compared the two versions. It might have been even better diffused.

BEAUTY WITH A BIT OF ATMOSPHERE

This picture also was taken in the South. The whiteness in the background is one of those lovely, old plantation houses. They have a style and feeling all their own, which always makes me think of the movie *Gone With the Wind*, and how enticing were both Scarlett and Rhett.

This is a totally rigged-up "period" photograph, although the period it portrays is long after the fall of Savannah. It's more like the Roaring 20s, which is when the model's dress and hat actually were made. Both were bought in Asheville, North Carolina.

The picture is taken by natural light, with a huge number of large fill cards. The model was sitting in the shade under a tree, because the direct midday light was too

harsh. All around her (outside the frame) were 4- × 6-foot sheets of white foamcore. There must have been about six cards, some lying flat on the grass, the ones at the edge tilted slightly up from the outside. The cards probably covered 15 square feet. A couple of them were placed right underneath the table and chair.

What these cards did was to raise the level of light under the tree, and change its angle. Instead of the light only coming from above and through the leaves, it now bounced back on the model from below and all sides. However, although it was brighter, you can see by the washed-out house in the background that the light was much less bright under the tree than directly under the sun.

The fill cards also helped to change the color of light under the tree. Normally, light coming through leaves has a distinctly green cast, which looks terrible. But because light also was reflected onto the model from outside the shade of the tree, the picture was less green.

I took many pictures of people on this set—using one, two, or three models—but I like this one of the single girl best. Her pose is great—it really shows the lacy gloves—and her look suggests all sorts of things, like a handsome man, or something else interesting, right outside the picture. The etching in the teacup looks well with the lace, and the blown-out white scarf and background give the picture a bright, optimistic feeling.

call this picture "flower heads," although it's a funny name. Judith Angel, my studio manager, and I actually made the hats on the models' heads. Judith makes a lot of clothes, and suggested we make flower hats out of some leftover satin scraps. I'm not sure why we made them, but they are unique.

The two models in this picture came to see me separately, a few days after Judith and I finished the hats. I showed the hats to them, and we all agreed to do a test shooting of "flower heads."

For the set and lighting, we built what's called a "tent." This time, it was a small tent, although sometimes we build a big tent for paid jobs. The girls lay down inside this tent. Besides the hats, they wore silky robes. We dressed the inside of the tent with a lot of satin sheets in different pastel colors. Deborah Steele did the hair and makeup.

The "tent" is a lighting setup used for shots of still life and people, and for many types of photography, because it creates an even, multidirectional light. Today, tents are most commonly big boxes of white foam-core, set up inside a studio. The white surface covers all six sides—front and bottom, as well as the rest—and the photographer shoots through a small hole in the front side. Inside the box is a group of strobe heads, usually firing into the four corners of the top. Light from the strobes bounces all over the place, reflects back from every direction, and fills all the shadows. The result is smooth and even, and—with a slightly bright exposure—also soft.

The term "tent" probably comes from a similar setup for very even lighting. In that setup, translucent white cloth is suspended around all sides of the subject. Strobe heads are spaced evenly around the outside of the cloth tent, and fire through it to light all sides of the object. Again, the photographer shoots through a small hole in front.

The picture is slightly diffused (with a No. 1 filter), although the diffusion is not readily apparent because of all the light, pastel tones. I also photographed the same scene with Ektachrome, push-processed for a grainy effect, but somehow this shot with normally processed Kodachrome 25 worked best. I love the tones, the girls' expressions and poses, and the whole photograph conveys the mood expressed in advertisements for certain brands of perfume. It is very similar to photographs in one of Sarah Moon's campaigns.

T W I N B E A U T Y

These girls, Ann and Amy, are identical twins. However, they are photographed from different angles—one almost in profile and the other full face—and their makeup and clothing are subtly different. One girl is in orange tones, while the other is in purple.

That is the twist—two identical women photographed together, but differently—that makes this picture work. It's a beauty photograph, but one that contains something unusual.

The lighting was soft and simple. The main light was a strobe head in an umbrella with diffusion material, positioned in front, but slightly to the right, of the models. A second light—a hairlight—was mounted on a boom and positioned above Ann's and Amy's heads. The light from this overhead umbrella brightened and defined the models' hair, and illuminated the brown seamless paper background.

Amy and Ann were English girls working as models in New York. We talked about shooting a soft and dreamy photograph for ourselves, and this is the result. In Europe, especially France, the public and advertising agencies love soft, atmospheric photographs. I think this picture works really well. I'm only sad that Amy and Ann are no longer working as models in New York.

I end the beauty photography with this picture, because it's the prototypical beauty photograph—diffused, shot tight up on good makeup, and with soft, even strobe light. However, on top of all, this picture has a twist—two women rather than one. That twist, the unexpected treatment of a frequently formal subject, is what makes this photograph stand out as unique.

To succeed as a commercial photographer, you must know what you are doing, understand the realities of business and the marketplace, and not fall into the trap of slavishly following formulas.

Chapter 6

MANY LOOKS FROM THE SAME MODEL

It's incredible how many different looks one man or woman can have, and how many types of photographs you can take of the same person.

Under certain light, a woman will look young and innocent. Under another light, she'll look much older, more sophisticated, perhaps even a trifle sinister. If you put a good-looking man in a pool on a bright day, he'll look young, happy, and carefree. When the same man is dressed in a tuxedo, leaning against the side of an expensive car, he suddenly becomes an established businessman.

I work with the same models, over and over, because I like them and we have developed a good working relationship. They are my friends—I know their likes and dislikes. I know what they can do as models, and they know how I work.

When you work with the same models again and again, and they like the pictures you take, they learn to trust and understand you. It makes taking pictures so much easier when a model is willing to do what you ask, and understands what type of mood and picture you are trying to produce.

However, when you work with the same person often, you must remember to try something new. You must take chances, play with ideas, and take new types of pictures. Otherwise you're stuck and all your pictures look the same.

In this chapter, I concentrate on pictures of the same people. They are three models with whom I have worked many times—Molly, Maija, and Glenn. It's interesting and useful to see how many different ways you can photograph the same person.

M O L L Y

met Molly two years ago. She came to my studio one hot and humid summer's day. Wilhelmina Models had just begun to represent her, and she needed a number of good photographs to use for a portfolio. So Sue from Wilhelmina sent her to me.

The instant Molly walked into my studio, I could see she was wonderful. I liked her immediately—she was open, honest, friendly—and something about the way she looked and moved told me she would be great in front of a camera.

For the previous few summers, I had been teaching a week-long course in fash-

ion and beauty photography at the Maine Photographic Workshop. Every year, I took a group of people along to the Workshop to act as models for myself and the class. I asked Molly if she would be a model for that year's class. She said yes, so I called Sue to tell her that if Molly went to Maine with me, she'd end up with plenty of photographs for a portfolio. Sue agreed.

Since that lucky summer's day, I have photographed Molly many times, in many places and situations. Almost every time we work together, we get entirely different types of pictures. It is amazing how many

ways Molly can look. She can look innocent or elegant, pensive or bubbly.

The picture of Molly with the wet hair laughing and smiling on a red raft was taken that first summer in Maine. It is one photograph—a happy, healthy, carefree picture—from a situation I set up for the class and me to photograph. Molly was one of three models (Glenn and Maija were also among the models that summer), and the whole situation involved a lake, a seaplane, rafts and boats, different clothes, and lots of assorted props. The models and photographers had a great time bobbing around

in the little boats, and other images from that day are shown throughout this chapter.

The beauty photograph of Molly with her hair up was taken in my studio about six months later. I call it a beauty photograph, since it concentrates on her face, and really shows the wonderful quality of her skin. (For more about the special area of beauty photography, see Chapter 5.)

People often ask what factor I look for most in a model, and I tell them the quality of the model's skin. Somehow, bad skin always ruins a picture. I never have my pictures retouched, so I always choose a model with beautiful, unblemished skin over one with more striking features and poorer skin. Molly has marvelous skin, and that is one of the reasons I consider her such a wonderful model.

This picture was lighted by strobe. We had one huge bank light (with four heads) off to Molly's right, and 4- × 8-foot white boards providing reflected fill light from her left. Molly was standing six feet in front of a black velvet backdrop. We were careful to make sure none of the light fell on the background, even though velvet can absorb a good deal of light and still look pure black.

(If the background had been black paper, or black board, Molly would have had to stand further away, and we would have had to be more careful about light hitting the background.) We used a 135mm lens with a No. 1 diffusion filter, and Kodachrome 25 Film.

The lighting and photography were actually quite simple, a standard setup I use often for beauty shots. What really took time were the makeup and preparation. A professional makeup artist worked on Molly's face, and styled her hair. The dress was a wonderful, puffy, purple evening gown I had found in a used-clothing store.

The picture of Molly in the tight, gray-green sequined dress has another whole look—much tougher, perhaps more contemporary. It also shows how well Molly can move, and being able to move well and spontaneously in front of a camera is an important skill of a good model. The background for this picture is extremely simple—an available blank wall. The floor is singularly uninteresting, and some people might call it ugly. But Molly has taken an ordinary situation, with no props, and worked with it. She has used only her body and pose to bring the whole image together in a photograph you want to look at.

Reclining on luscious green grass in an elegant evening gown, Molly looks entirely different, like a sophisticated society woman gone slightly giddy. She is flashing a magnificent neck, strong shoulders, and highly refined chin.

Leaning over the back of a strong white horse, dressed in a simple white cotton dress with her hair flowing free, Molly looks natural and pure. She is still a beautiful woman, but her beauty is organic, and the look is a clean, simple, country girl, rather than a refined society woman.

The last two pictures of Molly were taken on the same cloudy, overcast day in North Carolina. The sky was dark gray, and the light was very low, so I exposed at a slow shutter speed and used a very large aperture. Somehow though, the soft, low light worked well for the pictures. The natural light barely caressed Molly's pale skin, casting practically no shadows. The backgrounds went completely out of focus at the large aperture, and there were no distractions from the model. These pictures prove you don't need bright sunshine to create effective images.

This is Maija. Like Molly, Maija came to me early in her career for test photographs for her portfolio. Unlike Molly, Maija wasn't brand-new to the modeling business. She already had done a good deal of runway and photographic modeling in Europe. But now Maija needed a portfolio that would appeal to the American market.

Like Molly, I loved Maija the minute I saw her, although their looks are very different. Maija has lots of freckles and a strong nose, is slightly older, with a more real, accessible face. Maija's face probably wouldn't work as well as Molly's for high-glamour beauty photographs, but her whole personality is better for what is called "illustration." Maija has presence, a strength in her eyes, and a personality that pop off the page. Maija also has beauty, but combined with an element of character that makes it believable. She is

fantastic, and, at the same time, you feel you can know her as a person.

Maija went to Maine with me the same year as Molly, and has gone back for the last two years. The first picture of Maija—with a basket of flowers sitting beside an old road—was taken with available light from the sky. It was taken during our first year in Maine, and the location was a hill near the town of Rockport, where the Maine Photographic Workshop is based. It is a location I call "Blueberry Hill," and though the picture bears a strong resemblance to a famous painting by Andrew Wyeth, I did not think of it when I took the picture.

I found this location during the first year I taught in Maine. I went driving to find places for the class to use, and came across this incredible old house, practically a shack, situated in the middle of a tangle of blueberry bushes on top of a high hill. It

was magnificent, and I had to use it. I went back to the Workshop and told the director, David Lyman, about the location. He said I couldn't go up there with the class unless I got permission. So I started driving around the area and asking who owned the house and field. It turned out that it belonged to an old, eccentric lady. I went to see her, and when she opened the door, she said, "I just saw you on television." She'd been watching a soap opera and I looked like one of the characters.

I didn't correct the lady, but just explained why I was there and asked if I could take my class up to shoot on her property. She said okay, and I've been going there every year since then. It is one of my favorite locations in the world. There is something magical about that hill. It really can't be put into words, but it shows in the picture.

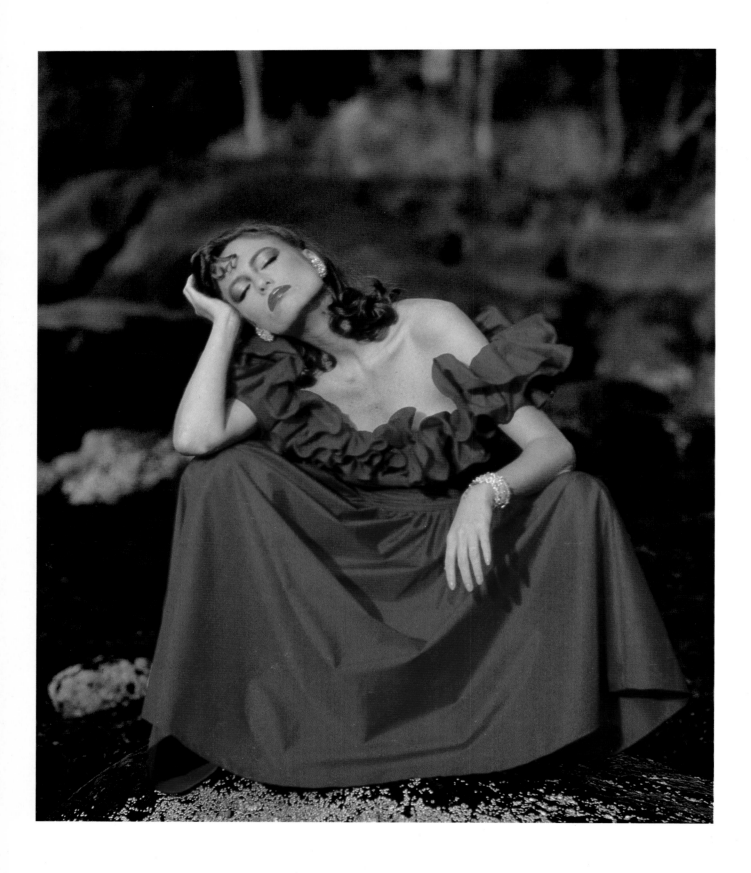

The picture of Maija sitting on rocks late in the day in an incongruously formal, red dress was also taken in Maine. It was shot down by the sea, and what makes it work is a combination of the warm red light and Maija's ability to know how to pose and pull the whole thing together. This is the same woman sitting primly with her flowers in the previous picture, but her personality and the message of the picture are entirely different.

The picture of Maija on the porch is from Maine, but taken two years later. The porch is actually part of David Lyman's house. The dress I bought in a bargain store and brought to Maine. The flowers were picked minutes before in David's front yard. They are nothing but weeds, but work well with the white wooden house. The picture was taken under available light on a cloudy, but bright, summer day. I used a diffusion filter to soften the whole scene, and a 135mm lens. And Maija—the model—knew just how to move with the setting and flowers to produce a very dreamy image, a fantasy with a touch of idealism. She looks like a dream come to life.

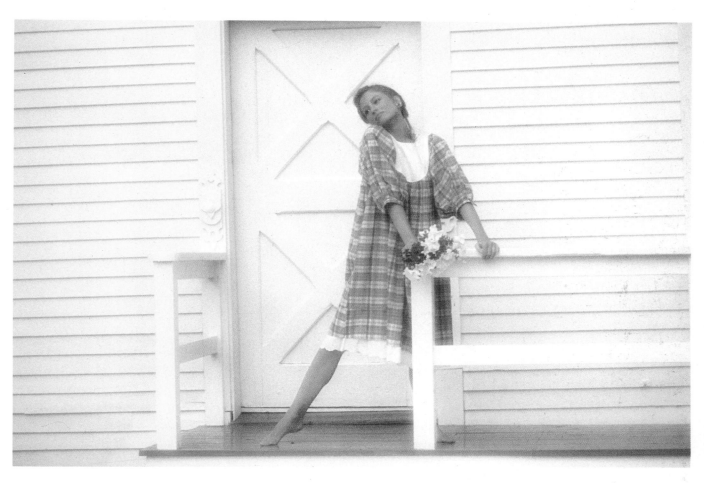

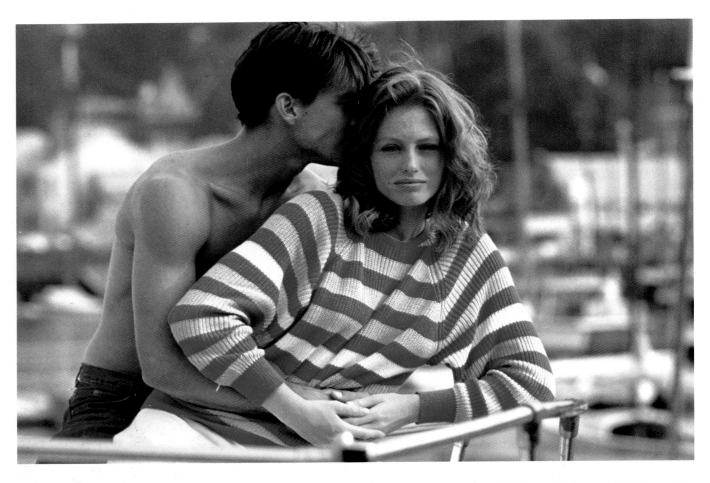

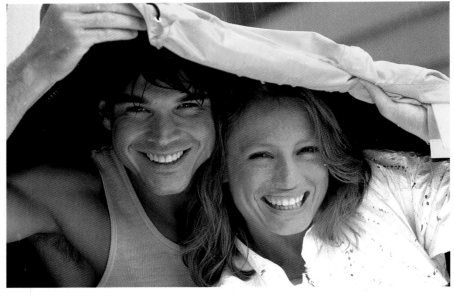

Maija, with the guy on the boat, is a whole different person. She's a sexy, sharp, and strong Maija. Her eyes and face confront the viewer directly, and the warmth of the late afternoon sun works well on both her and the man's skin. You can see all her freckles here, but they fit the scene. This is a commercial photograph, which could be used to advertise any number of products. This picture was part of a test shooting on a boat in a marina in New York State. I was standing on the dock next to the boat, and used a 105mm lens with Kodachrome 25 Film and no extra lighting or filters.

The image of Maija laughing under the yellow slicker in a simulated rain is also very commercial. Taken the same day as the picture of her on the boat, it has a fun, natural feeling, with a lot of animation. You can see lines in her face—laugh lines—but she still looks beautiful and healthy. She is an entirely different Maija from the dreamy woman on the white porch with flowers.

This picture looks a lot like a spontaneous snapshot, and the feeling of casualness and animation may be what makes it work. It is not a snapshot, but a very structured image. There is a huge difference, a point I have made before in this book. This picture is sharp and clean. There are no distracting elements in either the foreground or background, and there is one bold dash of bright color. The rain is simply water splashed on the models by an assistant. The raincoat is a yellow slicker we brought along as a prop, in case we could use it on a bright day.

There is a good deal of fill light reflecting into this photograph from the white deck of the boat. It is needed to show the model's faces underneath the slicker. If the only light hitting them were the light from the sky, they would have been in too dark a shadow. The lens was a 105mm, and the film again was Kodachrome 25.

Maija on the porch in a white dress is another sexy Maija, perhaps more natural than she is on the boat, but also very pretty. Again, you can see her freckles and her eyes jump straight out at you.

Maija is a very capable model. She can go from one extreme to the other with no trouble—from dreamy and elegant to warm and real, natural and pure. All you need to do with a model like Maija is set up the situation, and then let her "do her thing." It is always pure joy.

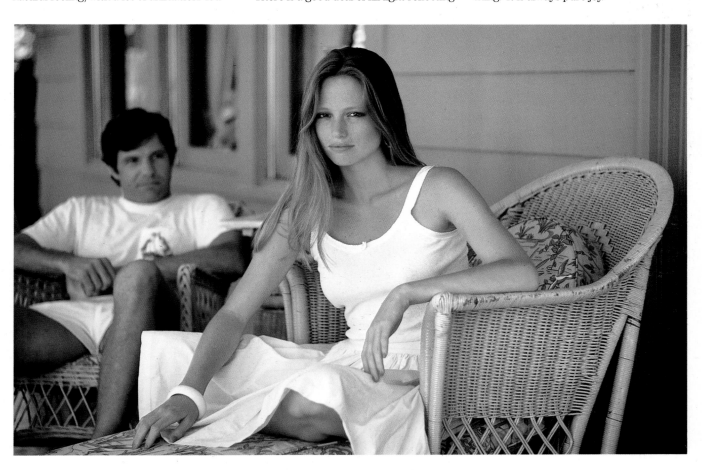

Glenn was my assistant. He carried around lights and reflectors, kept track of cameras and rolls of film, and went out to get everybody lunch. (The life and job of a photographer's assistant is complicated, and could be the subject for a number of books.) One day, I decided to put Glenn in front of the camera.

Glenn actually was working as the assistant for another photographer that day. Barry Schine, a still-life photographer, was renting part of my studio and Glenn was helping him with the shooting. In another part of the studio, I was testing the new Kodachrome Professional Film for Kodak before its release to the public. I was working with a model, Candy, and ski clothes. But the pictures weren't coming out right. They didn't have the feeling of life I wanted. So I asked Barry if I could borrow Glenn for an hour.

I didn't give Glenn a chance to say no, but put him in the picture before he had a chance to get nervous. "Hug this girl," I said. "You certainly can hug this girl, right?" He did, and was perfect. Kodak bought the picture for advertising, and later bought additional rights to publish it in a brochure. Glenn and Candy were paid as models. I was paid as the photographer. It was the first professional photograph for which Glenn had ever posed.

This picture is typical of a studio situation. It was illuminated by two heads bounced into four white flats in front of the models. The heads are behind the models and the flats in front, with a small slit for my camera. It is the light that produces no catchlight in the eyes. The background was a piece of blue seamless backdrop paper illuminated by another strobe.

The picture of Glenn lying in the arms of a gypsy woman (Molly) is very different.

First of all, he's wearing a fake mustache. Actually, it's real human hair, but glued on with rubber cement. Also, the lighting—real sunlight—is much simpler, and more real than the studio strobes. At the same time, the styling, props, and situation are more elaborate and involved.

Deborah Steele, a professional makeup and hair stylist, had a lot to do with this image. We set up a whole fantasy gypsy scene. It involved a tent, six models, a fire, lots of lanterns and props, a horse borrowed from a nearby farmer, and much more. Deborah played a part as the fortune teller. Everyone had a great time, and all the neighbors stood around and watched.

Here, Glenn is the dark and handsome stranger. He has a mustache, and his hair is dark with dye combed in by Deborah. He's wearing a simple white shirt, but his hand is resting on an unusually decorative accordion I found in a nearby antiques store.

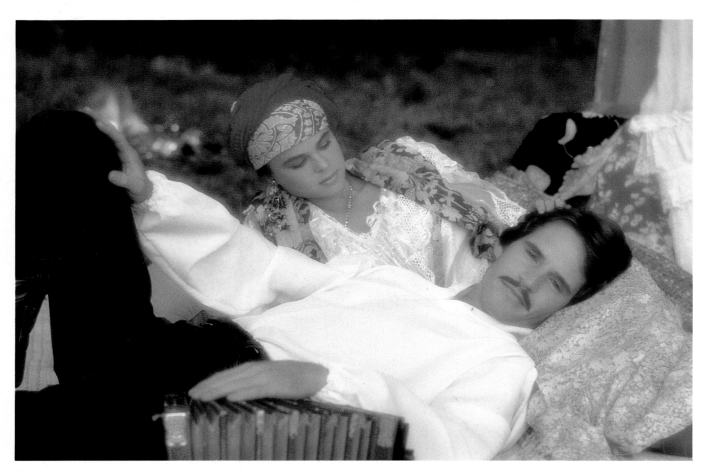

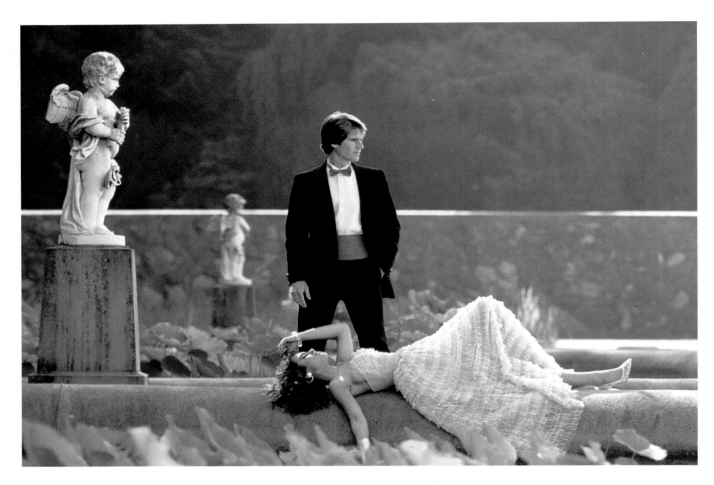

The picture of Glenn wearing a tuxedo with a red bow tie and cumberbund was taken outdoors in North Carolina. The only light was soft light from a gray sky, but somehow the picture works. The location—the Vanderbilt estate—was great. Glenn and the woman got in the proper mood immediately. They posed with what some people call "attitude"—confidence, with an air of diffidence and aloofness. It's one of the best and most difficult things you can ask a model to do.

The picture of Glenn with the woman in the purple-and-black dress was more complicated in terms of the setup and lighting.

The models actually are sitting on a large (4- × 8-foot) sheet of white plastic mounted on top of a thick sheet of glass, placed on top of wooden sawhorses. Behind them is another 4- × 8-foot piece of white Plexiglas, suspended vertically and butted up against the sheet on top of the sawhorses. The light blows out the seam. (There's nothing to hide.)

Underneath the whole thing we placed two strobe heads. There were another two heads behind the background sheet. In front of, and slightly above, the whole thing was another strobe bounced out of a big, soft umbrella and further diffused with

translucent Pellon. I wanted a really bright white, with a bit of reflection. That's something you can't get with white paper, no matter how hard you try. The lens was a 105mm, with a slight diffusion filter, and we had to be careful the whole thing didn't collapse when the models eased onto the Plexiglas.

We kept the setup for two nights. The first night, everyone wore white clothes. You can see almost nothing but the people's faces. The second night, I made people wear black clothes, or clothes with a good deal of black, and I like how the pictures turned out.

In this picture, Glenn as an athlete is much tougher. This is obviously a studio shot, taken in a little studio set up for a class in Asheville, North Carolina. It was quite simple—a background of blinds with one strobe behind them, another strobe bouncing out of a silver umbrella straight onto Glenn's face, and a very strong hair-light above him. It is a very hard, hot kind of lighting. We used the same setup to take pictures of two other girls, but this one worked best. Before we took the picture, Glenn did a lot of push-ups to pump up his muscles and get a bit of sweat. That's what is done for all the muscle and fitness magazines. Right before being photo-graphed, the guys work out heavily, and get all pumped up.

The final picture of Glenn—with wet hair and laughing with Molly—comes from the same shooting in Maine described at the opening of this chapter. It was a great day, and toward the end, I climbed right onto the seaplane they were on and took some close-ups. The sun was low in the sky, and cast a lovely red, warm light. Glenn looks really young here, much younger than in the tuxedo pictures.

All these photographs were taken in the same year, after the first shot of Glenn with the girl in ski clothes. But Glenn looks very different in each shot. He looks like a young kid, or an older man. He looks natural, or sophisticated. You might not even recognize him in the profile shot on page 86. But each picture is of Glenn—once my assistant, and now also a model with an agency.

Getting different pictures from the same person is partially a matter of lighting and clothing. It's a matter of photographing him or her from different angles, in a wide range of situations. It's also a matter of seeing the person differently, and working to reveal various personality parts. Finally, as some-one learns to be a better model through experience and exposure, he or she begins to do more things, to learn about different looks, about "attitude."

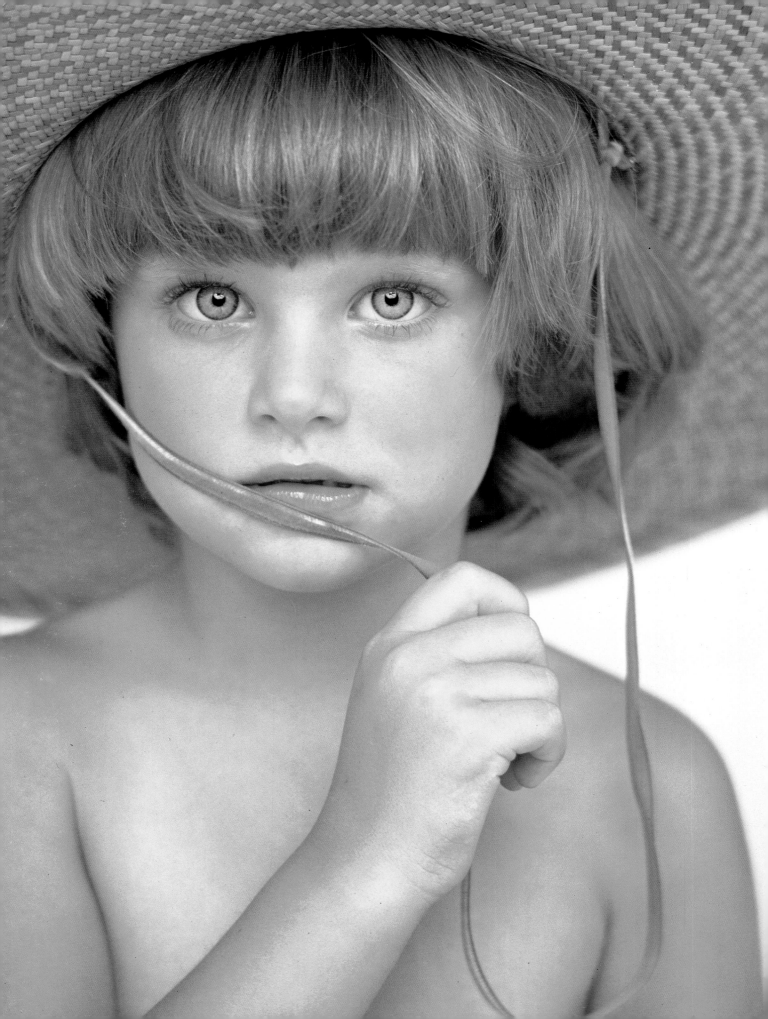

Chapter 7

TURNING SAMPLES INTO JOBS

If someone asked me to give one sentence of advice on how to become a successful professional photographer, it would be: "Shoot a lot of samples."

I can't even begin to tell you how important to my career have been the pictures I've taken on my own. If I hadn't shot samples and done tests from the beginning, I never would have become a real professional, or received my first paying jobs. Even now, when I have drawers filled with tearsheets of photographs that have been paid for and published, I feel it's crucial that I continue to shoot samples and do tests.

My samples really show what I can do as a photographer, while tearsheets only show what someone hired me to do. It is my samples that give art directors confidence in my abilities, offer them ideas, and give them reasons to hire me, rather than another good photographer in New York City. Samples lead directly to jobs, and I can't stress that point too strongly.

Perhaps even more important, samples give me an excuse to take my cameras out of the cabinet. They give me a reason to take pictures more frequently than do paid assignments—and I honestly love to take photographs, which is why I got into this business.

Samples also give me a chance to experiment with new ideas, and techniques, and to meet new people—things I love to do. Assignments, on the other hand, are very different. Assignments are not the place to experiment, but the place to play it safe. The client is spending a lot of money, and you can't afford to take chances. You must do what you know how to do and what you are sure of, because you can guarantee the results.

Samples also sell well as stock—as existing pictures. Many of the photographs I've shot on my own have been picked up for posters, postcards, and even advertisements. Some of them have generated good income, which is especially gratifying when I've enjoyed taking them.

This picture is one of my favorite sample shots. Kodak loved it and used it as the full cover shot on one of the issues of *Kodak Studio Light*.

When I was first learning about studio lighting. I decided to experiment with making an absolutely shadowless picture. To do so, we built a large box out of foamcore—with bright white walls on all six sides—and placed strobe heads in each of the four top inside corners. One of the walls (the front) was removable so we could get inside, and it had a small round hole through which we could photograph.

We had a dark blue string hammock and I thought it would make an interesting graphic element against a bright white background, so we decided to do a test of a girl in a white dress lying in the hammock. The idea was to blast the picture with light, and wash out a good deal of the dress, so when I called the people at my old agency, Zoli, I asked them to send me their tannest model. The shot just wouldn't work if the girl were pale—we'd probably lose her skin, as well as the dress.

Zoli sent this girl and she was perfect. She looked great in the dress and white hat. When we got the chromes back, I liked the picture so much, I decided to publish it in a promotional mailer. Almost five years later, an art director from the advertising agency for Pentax USA—Campbell Mithun— called and asked if we had used a Pentax camera to take this picture. If so, he wanted to buy the rights to reproduce it in an advertisement for Pentax.

I hadn't used a Pentax, so we arranged for me to reshoot the same picture, with some slight changes and a Pentax camera. Thus, this lighting test became a whole new assignment with its own production budget, a fee for the model, and all the rest. Pentax used the new photograph, not only for an advertisement, but also for a limited-edition poster signed by me. I also later photographed another advertisement for Pentax.

We enjoyed redoing the shot, as it gave us an opportunity to work with the idea again, and improve on our first try. David shot the still-life of the lenses and, along with the model's face reflected in them, they were stripped into the larger picture during printing.

NANCY BROWN (212) 675-8067
6 W. 20 ST., N.Y., N.Y. 10011

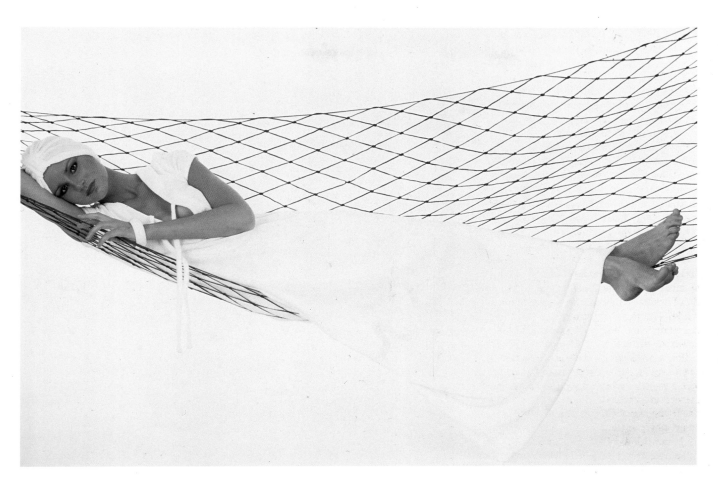

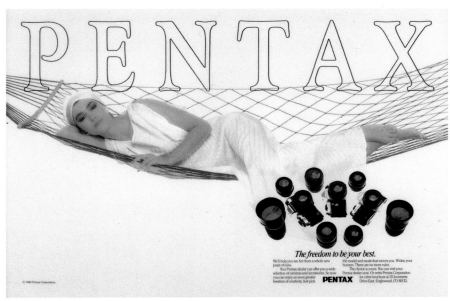

PENTAX

The freedom to be your best.

We'll help you see her from a whole new point of view.

Your Pentax dealer can offer you a wide selection of cameras and accessories. So now you can enjoy an even greater freedom of creativity. Just pick the model and mode that moves you. Widen your horizon. There are no more rules.

The choice is yours. You can visit your Pentax dealer now. Or write Pentax Corporation for a free brochure at 35 Inverness Drive East, Englewood, CO 80112.

PENTAX

© 1984 Pentax Corporation.

have a close relationship with some of the technical people who work for Kodak. So when Kodak introduced the new Kodachrome Professional Films, they sent me a case of the ISO 64 film to test and see how I liked it. I love the old, standard Kodachrome 25 so much that I was skeptical anything could be better.

We decided to test the new film, both in the studio and outdoors. This was one of our studio tests. You can see one of the outdoor tests—the shot of a couple in a bright red convertible car—in Chapter 4.

The model was a friend of mine, Angie. She wanted a body shot for her portfolio, a photograph that showed her figure more than her face or the way she wore clothes. So we decided to do a photograph of her in a bathing suit—red, of course.

Angie stood in this little, plastic kiddie pool I had bought years ago and have used for many "wet" shots. My assistant at the time, Kazu, stood on a ladder and poured water over her with one of those cans with a long spout and sprinkler attachment at the end, which you use for watering houseplants.

The background was a large sheet of translucent white Plexiglas, illuminated from behind by two strobe heads bouncing out of umbrellas. A third umbrella with a strobe was mounted on a boom in front of, and slightly above, Angie.

On the word "go," Angie looked up, Kazu started pouring, and I started shooting like mad. When the watering can was empty, Kazu climbed down, refilled it at the sink, and then we did it all over again, at least 20 times that night. Obviously, nobody helped on the hair and makeup, and the only styling needed was for a bathing suit that fit Angie beautifully.

I did this sample to test the film, and to give Angie a good shot for her portfolio, but when I showed it to the people from Kodak, they fell in love with it. They bought the rights to use it in advertising their new film. They even asked me if they could show it in a slide mount with my name on it.

So what had started out as a film test and sample for Angie's book became a well-paying job—and the best promotional piece you could ask for. I have no idea how much work this picture has brought me, but it's done a lot of good, and was worth the few extra hours we stayed in the studio.

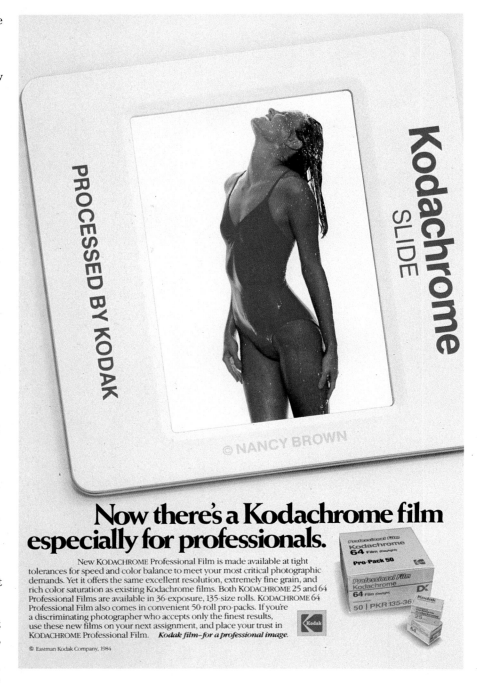

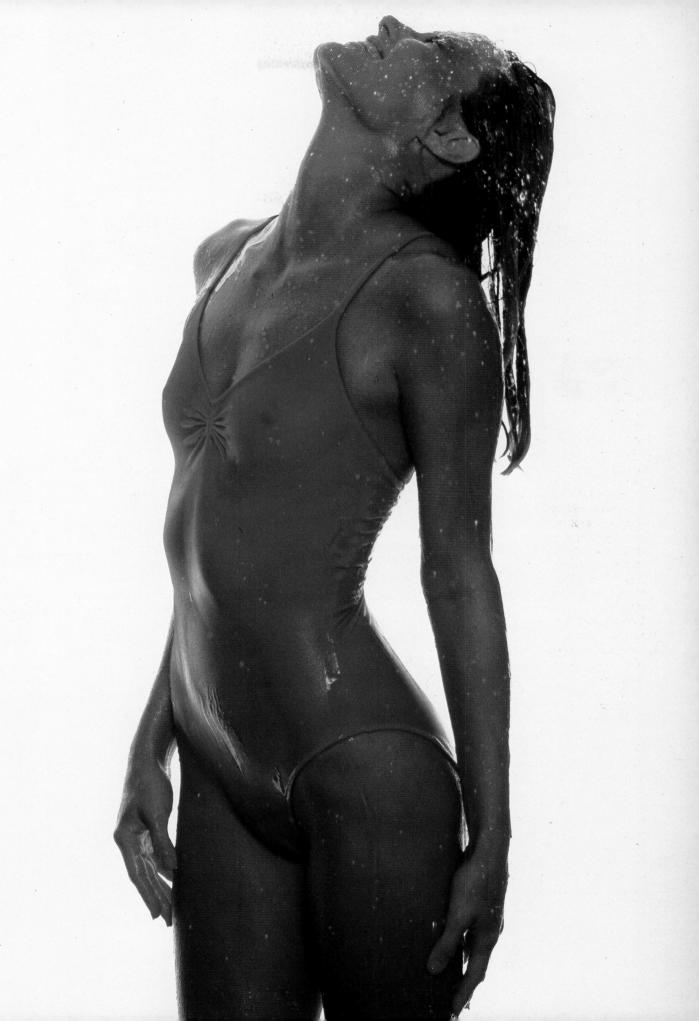

The
Cellulite-Free Body

Larry Melamerson

A 10·minute·a·day program
to smooth & trim your body

FOREWORD BY CALVIN KLEIN

We took this picture of a girl in a black bathing suit (or workout outfit) when the aerobics/exercise craze was starting a few years ago. I've always been into exercise myself—I ride on my stationary exercise bicycle each morning and go to the gym every other day—so I knew we had to have some exercise/dance-oriented samples in our book. There was bound to be a number of exercise-oriented photography assignments coming.

The picture was a simple studio shot—a model against black velvet lit by two strobe heads behind her (to separate her from the background), with their light reflected back into the scene by large flats in front of her. I really liked the graphics, and the way we arranged the silver poles crossing each other. It was an interesting twist on the classic ballet dancer's practice barre. I liked this sample so much, we decided to publish it in one of our advertisements in a creative directory.

About six months after the creative directory came out, we got a call from the art director of a major book publishing company. She had seen this page and picture, and felt it would be perfect (with minor changes) for the cover of a book. Were we interested? of course!

We took the picture again, with another model in a bright pink bathing suit. The lighting and background were exactly the same. The biggest changes were in the model's position, her hair, and the fact that we overlapped the lower horizontal pole in front of the vertical one.

The new picture worked perfectly for the book cover. Since that day, we've done a number of jobs for that art director. The moral of this story is that a good sample can bring you not only one job, but a new, good, and constant client with a lot of work.

This is another picture that I took completely on my own. It's another sample, another test of an idea. It's another picture that was seen by the people from Kodak and caused them to say: "We've got to have it. Can we buy the rights to reproduce it in trade advertising? Can we use it to advertise our paper to retailers and color labs?"

The original idea was something that might work for a cosmetics company—Revlon or L'Oreal—or something similar. The look would be clean and healthy, a young woman in the crisp winter air. A young woman with a blush from exercise, happy and confident after conquering the challenge of a tough ski slope. It would be a bright, clean picture with a very healthy, real feeling.

We went to Pennsylvania to take the picture on our farm, after a large snowfall. We drove out one sunny Sunday morning with a male and a female model, shot for most of the day, and then drove back to New York.

We wanted the pictures to be very real—beautiful and clean, but real. Being in the snow and crisp, clean air added something intangible. Also, the bright white snow worked like a huge reflector, bouncing the light back from the ground in all directions.

The model had beautiful hair—long, light, and fine—so we took advantage of it. We let it fall out of the cap (she probably would have had it tucked under if she were skiing) and blow all over the place. We backlit her hair by putting her in front of the sun, which added some glow. The exposure reading was taken from the front. We metered the reflected light striking her face, to be sure that her nice skin looked clean and bright.

We covered the situation (as we always do) by taking a lot of pictures in different situations. We did tight shots, like this one, and larger pictures of her falling down and laughing in the snow. We diffused some of them with a No. 1 soft filter, and took some without filters. In the end, the straight pictures looked better. The model's skin was so clear, it didn't need the diffusion, and somehow the sharpness looked best with the crisp air and the idea of a beautiful day on the ski slopes.

After the shots had been developed and edited, we put the best photographs in the stock house I worked with—The Image Bank. It was there that Kodak found this picture, and it was through The Image Bank that Kodak bought the rights to use it in an advertisement.

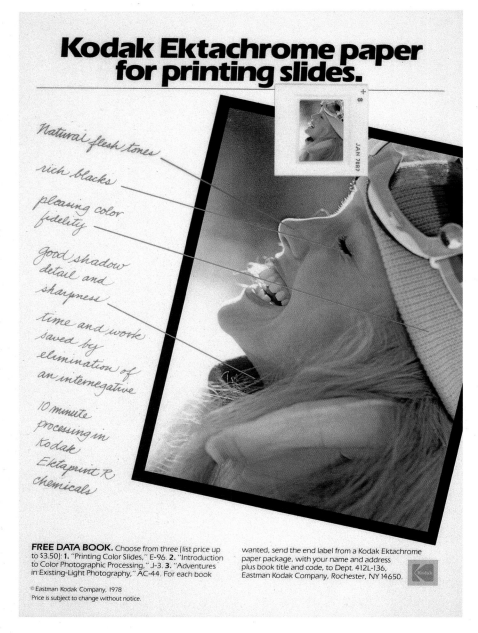

Kodak Ektachrome paper for printing slides.

Natural flesh tones
rich blacks
pleasing color fidelity
good shadow detail and sharpness
time and work saved by elimination of an internegative
10 minute processing in Kodak Ektaprint R chemicals

FREE DATA BOOK. Choose from three (list price up to $3.50): **1.** "Printing Color Slides," E-96. **2.** "Introduction to Color Photographic Processing," J-3. **3.** "Adventures in Existing-Light Photography," AC-44. For each book wanted, send the end label from a Kodak Ektachrome paper package, with your name and address plus book title and code, to Dept. 412L-136, Eastman Kodak Company, Rochester, NY 14650.

© Eastman Kodak Company, 1978
Price is subject to change without notice.

Chapter 8

SPECIAL PHOTOGRAPHIC
TECHNIQUES

Technique can be a trap. You can get so involved in fancy photographic equipment and techniques that you forget what you are really doing—creating images. You can forget the most important factor—what your final pictures look like. A perfect example are those guys you see walking around the park on Sundays with huge shoulder bags, and gigantic lenses mounted on their cameras. If you ask to see their pictures, they'll probably show you a shot of some boring doorway, and then talk about how far away they were when they took the picture: "I used a 1000mm lens, a 1000mm. And look, the doorknob is perfectly sharp."

Most of my pictures are quite simple, at least from a technical point of view. As a matter of fact, I try to keep my technique as simple as possible. I don't believe in making things more complicated than is necessary. It just doesn't make sense.

Sometimes I'll use long lenses, a complicated lighting arrangement, or have my film developed in an unusual way. But I only use special techniques when they create a better, stronger image. The picture always comes first. After all, technique is only a tool.

One final, very general, comment about technique and the technical aspects of photography. In general, I like a clean picture, a sharp and crisp picture. I also love the color white—my apartment, my studio, and many of my clothes are white. I study the whites in my photographs very carefully, and use them as a control—a yardstick—with which to measure the exposure and color quality of my pictures. The whites must be clean, pure and, at the same time, must have enough detail to show what I want in the picture. I hate dingy whites, and when I get them, I know I have to adjust my technique.

SIMPLE STUDIO STROBE LIGHTING

The simplest type of studio lighting is a single strobe head reflecting out of a large white umbrella. It's amazing how much you can do with one umbrella. You can use it for fashion pictures, beauty shots, portraits, even still-life shots. The only other things you need are good backgrounds and models.

There are three basic types of umbrellas: silver-lined, white-lined, and white translucent. With silver-lined and white-lined umbrellas, you bounce or reflect the light from the strobe head out of the inside of the umbrella. Silver-lined umbrellas have more "kick" and white-lined umbrellas produce a softer, more even light. With translucent white umbrellas, you fire the strobe through the umbrella, for an even more diffused softer lighting effect.

I often use a large, white-lined umbrella as the primary light source for my pictures. I usually place it slightly above, and to the side of, my models. For dramatic lighting, I place the umbrella more to the side.

Usually, I counterbalance a single umbrella by placing a 4- × 8-foot sheet of white foamcore on the other side of the frame from the umbrella. This reflects light back into the picture, filling in the shadows without eliminating them entirely, and cutting down the contrast of the whole scene slightly.

As a further refinement, I add a hairlight—another strobe in a silver-lined umbrella (wrapped with a sheet of Pellon to soften it) above the models. This light fires down on the heads of the models, highlighting their hair and separating it from the

background. Adjusting the intensity of this hairlight is easy. We just move it up and down, depending on the color of the background and color of the model's hair. For blondes, the hairlight is moved up, since their hair doesn't need as much light to stand out. For dark-haired models, we move the umbrella down closer, increasing its effect.

Both of these pictures were taken with that simple setup—one main umbrella, reflectors, and a hairlight. The background for the picture of the girl in the antique dress with the doll was black velvet. The background for the mother and son was red seamless paper. These aren't elaborate pictures—the lighting and sets were quite simple—but they work because the models have good expressions.

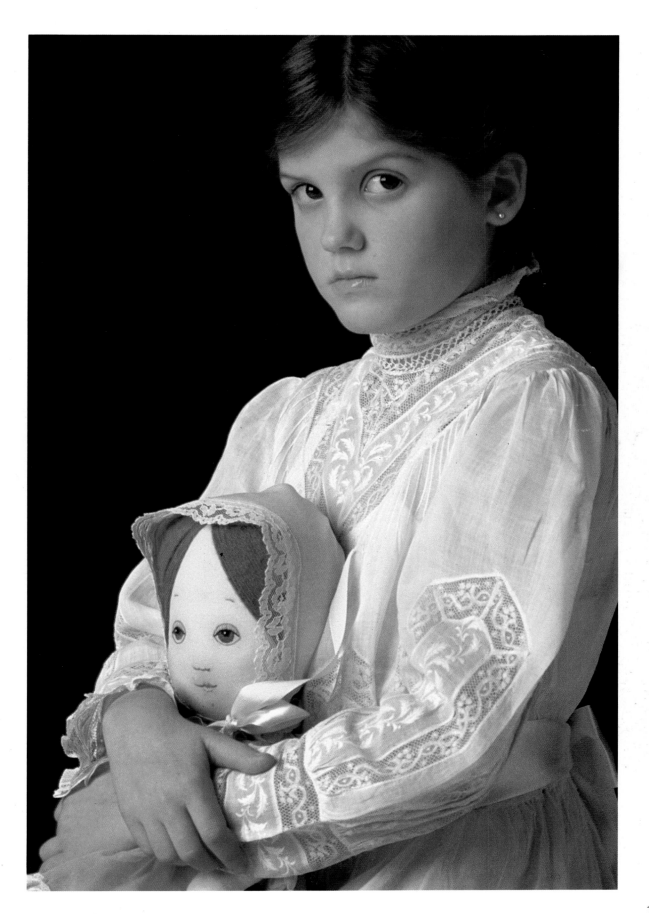

This is a simple and versatile arrangement that I use often for portraits and beauty photographs. I call it my "headshot booth." It's quick to set up, easy to use, and works beautifully. Also, since it's the same every time, I know exactly what the results will be.

At the center of the booth is a white-topped, adjustable, designer's table, the kind you can buy in art-supply and office-supply stores. The key is to get one that is easily adjustable and then it can be used for many types of pictures.

Behind the table, we put a stool for the model to sit on, and a roll of seamless background paper behind that. The roll is mounted between two light stands, and can be any color. Then we prop two large (4- × 8-foot) sheets of white foamcore against both sides of the table. These lean against the edges, and one is pulled out of the way to allow the model to step inside and then repositioned in place.

Now comes the lighting equipment. First, we put up the hairlight—a strobe head above the model, with a small scrim of black cardboard that keeps this strobe from firing directly into the camera lens. This strobe is mounted on a light stand behind the booth, and can be moved up and down easily.

For the main light source, we use either a bank, another strobe reflecting out of a small umbrella (shown here), or a larger, softer, white-lined umbrella. This light is mounted on a boom, and positioned above in front of the entire contraption.

What happens is that the light from the main umbrella and the hairlight bounces around inside the booth, creating a very soft, multidirectional, and flattering effect. It reflects off the two sheets of foamcore onto the sides of the face, and off the white table to fill in underneath the chin and eyebrows. The hairlight comes down directly onto the top of the head to help define and add interest to the hair and shoulders. With a black background, it also helps to visually separate the subject from the background.

When we want a little more "kick" or sparkle, we'll put a bright silver reflector card on top of the table. We did that for this picture of Susan wearing a blue sequined top, and you can see how the bright silver makes the sequins shine, and the earrings sparkle.

This is one of my most basic, standard, studio setups. I devised it years ago, and use it at least once a week. My assistants can set it up in about three minutes flat, and I always know how the lighting will look. This leaves me free to concentrate on the model's expression and makeup, and the styling of the picture.

his picture was taken on location in an auditorium/screening room near Chicago. The popcorn and container came from a nearby movie theater.

It was a medium-sized screening room, and this picture is a good example of a lighting technique we use often for large sets or large interior locations. The basic idea is to flood the entire room with even, bright light. This enables you to photograph the whole place or any part of it, without having to change and recalculate the lighting. (If you used a few directional umbrellas, or even banklights, you would have to move them for each different picture.)

In this particular instance, we placed one head in each of the four corners of the auditorium—facing into the corner, and firing at both the ceiling and two side walls. (The ceiling was painted bright white here. If it hadn't been, we would have taped white board or white seamless paper to it so the color of the bounced light would not be changed by the color of the ceiling.) In essence, we turned the entire place into a light tent. Because this room had a large, bright white movie screen at one end, we also bounced two strobes off the screen— creating a broad light source like that of a bank light, and adding more direction to the light than would be produced by four heads off the corners alone.

You can use this technique to light almost any small-to-medium-sized room or large set. If the set has white walls and a white ceiling, bouncing strobes out of the corners is a great way to light the place evenly.

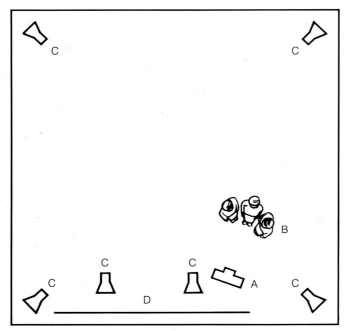

A: Nikon 35mm camera with 85mm lens
B: Subjects
C: Calumet strobe heads with 9″ reflectors pointed away from subjects
D: Movie screen

USING TUNGSTEN LIGHTING

Strobe lights are powerful, cool, portable, and balanced to provide correct color with daylight film, but they are not the only source of artificial lighting. You also can use continuous tungsten and quartz lights, which are called "hot lights" in the business.

I love to use tungsten light. It has a whole different feeling than strobe light. Most obviously, it is much warmer—redder and more orange—than strobes. Also, because the light is continuous, you really can see what you are doing, and have the additional possibilities of using motion and blur. The drawback to tungsten lights is that the bulbs get hot, which can become very uncomfortable for both you and the models. Tungsten lights usually have less power than strobes, so you have to work at slower shutter speeds, and at larger apertures with less depth of field.

There are three main reasons to use tungsten lights: to produce a picture with golden light that looks like it was taken early in the day or at sunset; to get the feeling of a nighttime scene taken with available light; or to warm up the skin of a pale model and make it look tan.

Both of these pictures were taken in the studio. The picture below of Nicky Winders and Phil English was taken because I wanted a sample that said "nightlife," one with a feeling of elegance and glamour. Tungsten light was the technique that did the trick. It really looks as if the couple had just come out of the theater, or an expensive Italian restaurant. The light looks as if it were cast by car headlights, spotlights, or a bright theater marquee. Nicky did her own hair and makeup, and I was the stylist, as well as photographer.

In this picture, the spotlights (Lowel lights) were behind the models, aimed at the back of their heads. The background was a large sheet of black velvet, and two large sheets of white foamcore were di-

rectly in front of Nicky and Phil. The spotlights hit their hair and the sides of their faces directly—highlighting and causing them to glow—and then struck the white flats. The light reflected back from the flats onto the front of the models, illuminating their faces and clothes. There was also a strobe right in front, set to low power. This strobe helped to keep the picture from becoming too orange, and put catchlights in Nicky's eyes.

The picture of Jon with the canteen and sunglasses, in front of a painted backdrop of the pyramids, was taken under strobe lighting—but the strobes were covered with Rosco gels to give them the 3200K color temperature of tungsten lights. The backdrop was illuminated by four umbrellas, and Jon was lit by a fifth umbrella placed high, to the side, and slightly behind him. It looks more like the even light cast by a sunset, and gives the picture a feeling of desert heat.

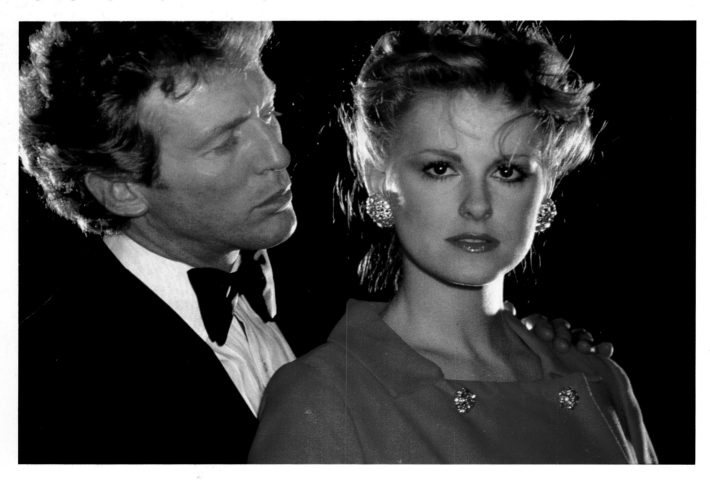

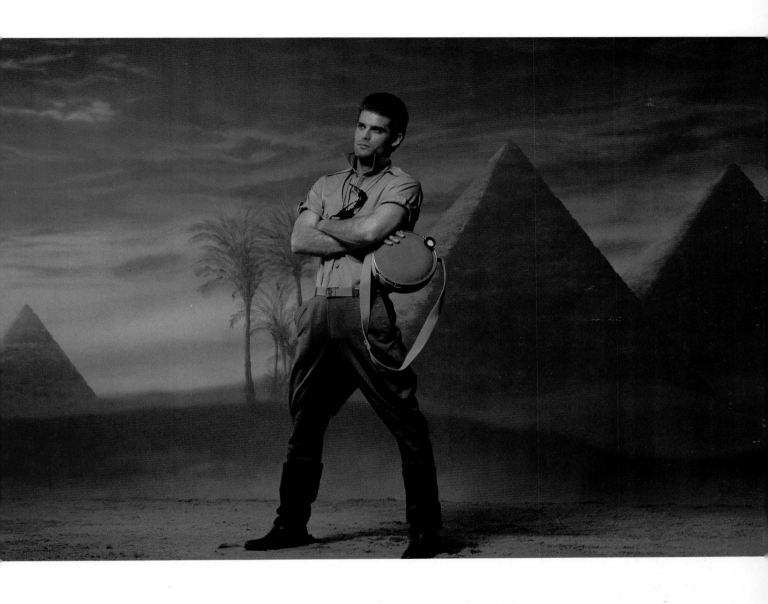

MIXING TUNGSTEN AND STROBE LIGHTING

One of the things I particularly like is to mix tungsten light with primarily strobe lighting. The combination allows you to show motion, and creates additional interest in the picture. It also has a very real look—much of what you see in life is seen under a combination of different light sources.

The picture of the couple in front of a sunset sky also was taken with a combination of different temperature/colored light sources. Two strobe heads covered with orange gels were placed slightly behind, and on the sides of, the models. Another strobe (without gels) was bounced out of an umbrella mounted on a boom above and in front of them. The background—painted by Sandro La Ferla—was lit separately by two more strobes (without gels and one on each side) in umbrellas.

We do this often—use tungstenlike light for backlight, and daylightlike strobes for the front. That way, the tungsten just comes in and hits the side of the faces and hair, while the strobe lights the clothes and faces. It gives the best of both worlds—a nice, warm orange feeling in localized areas, as well as proper skin tones and clothing colors. It worked especially well for this picture, because the sunset was supposed to be behind the models. In real life, people standing in front of a sunset would not appear orange from the front.

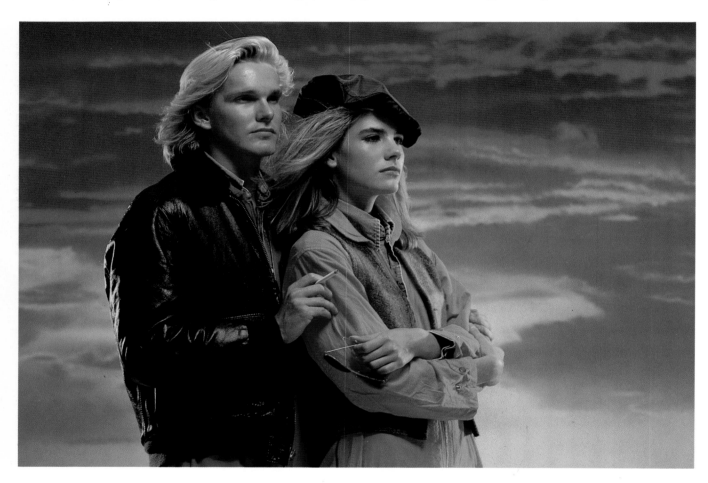

For the picture of Maija on the swing with Jon dressed in my favorite men's outfit—black tie—we combined tungsten with strobe lighting to create a feeling of motion and to add some uncommon element to the picture. It looks like it might have been difficult to do, but actually it was quite simple. The hardest part was swinging Maija into the frame a couple of hundred times, until everything was right.

What we did here was to set up a tungsten spotlight off to the right side, and a strobe head in a large umbrella in front of (almost dead center), and slightly above, the male model. We set the camera's shutter on "bulb," and balanced both lights so they provided proper exposure at an aperture of $f/5.6$.

I almost always use an aperture of $f/5.6$, unless I need a lot of depth of field. Rather than set the lens opening to correspond with the lights, we regulate the intensity of the lights for proper exposure at $f/5.6$.

On the word "go," I opened the camera's shutter and an assistant swung Maija into the picture. At just the right point (at the peak of the action when she virtually stopped in midair), another assistant fired the strobe manually. Then I closed the shutter. The result was that the tungsten light illuminated Maija as she moved, and then the strobe came in and froze her, Jon, and the swing.

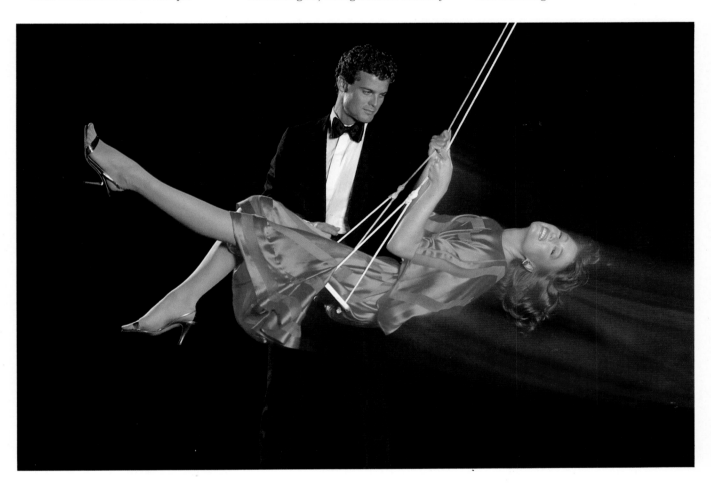

STROBE WITH A TUNGSTEN EFFECT

This picture was taken with electronic strobe lights—Balcar strobes—but many people think it was taken with tungsten lighting. Balcar has Pyrex shells that you put over the tubes of the strobes to change the color temperature of the light and get the warm, orange effect. Advantages of this system are that it is more comfortable for the models than hot tungsten lights, and you easily can get more power than tungsten lights usually provide.

There are three ways to get the tungsten effect: You can use real tungsten lights, like the ones that Lowel makes; you can put colored gels in front of your regular strobes; or you can use this Balcar system. I use all three techniques, depending on which works best for the picture.

You also can get an orange effect by using a filter in front of your camera lens, but I never do that. I like to use as few filters as possible, and I don't think an orange filter really works. The whole picture is too orange, and it looks fake. Everything is not an even orange color under a real sunset, or in a nighttime scene. There are still clean whites in the brightest highlights.

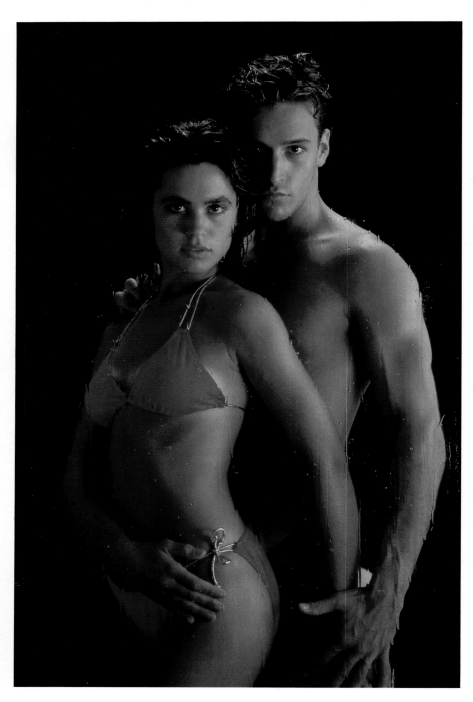

The models in this picture, Nancy and Doug, were behind a piece of glass. They were wet, but we also trickled a combination of water and glycerin on the glass. Using glycerin instead of water (or mixed with water) is an old trick of still-life photographers. Glycerin forms beautiful drops, whereas water just spreads out. In a case like this, the glycerin ran down on the glass, and then stopped. Water would have run down and off the glass.

We had to be very careful where we wet the glass. We didn't want the droplets in front of the model's faces, and also wanted the pattern to work with the shape of their bodies. We took this shot with the models standing up, and the sheet of glass vertical, but if we had wanted to have a designed effect with the drops, it would have been better to have the models lying on the floor with the glass above them, flat and horizontal. That way, the drops would have stayed exactly where we placed them.

Two strobe heads (with Pyrex shells) were positioned behind the glass and nearly parallel with the models. They fired through a large sheet of parachute material to diffuse them and give the effect of a banklight. This light source was carefully feathered (shielded) with large black flats, so no light struck the glass directly. If it had, the glass would have turned into an orange mirror, or a flaring highlight.

On the opposite side of the models were two large white flats (close and just outside the edge of the frame). These flats reflected the light from the strobe bank and illuminated the side and front of the models. There was a hairlight (with a Pyrex shell, and carefully feathered) above the models. The lens was a 105mm.

WORKING WITH PAINTED BACKDROPS

Canvas backdrops designed for photography are painted as if they were lighted. They have shadows and highlights on them, and give the impression that the scene depicted contains a particular type and direction of light.

This makes backdrops very easy to light. All you have to do is illuminate them evenly. You don't have to worry about the direction of the light on the backdrop, but just make sure it is even all the way across. For small backdrops, we normally use two strobes—evenly spaced on each side—with umbrellas. For larger backdrops (and some can be huge), we use four strobes, two on each side. We test the evenness of the

lighting by taking light readings in many areas, and shoot tests with Polaroids.

The harder part is in lighting the models (or set) in front of the backdrop. You have to light them in a way that ties in with light painted on the backdrop. If it has a particular direction or quality, you have to match that quality with your other lights. If the light in the backdrop is coming in strong from the left, it's a good idea to light your model primarily from the left.

One of the biggest problems with many backdrops is tying them into the rest of the scene or set—integrating them with foreground objects in a realistic (or effective) manner. Some backdrops come with their own floors, or are designed to be used in a

sweep like seamless paper, in which the bottom of the backdrop becomes the floor. But many don't, and then you are limited to photographing the models straight on against the backdrop and cutting them off at the knees—or you have to build an appropriate floor (and find a way to hide the seam between the backdrop and floor).

Two final comments about backdrops: You shouldn't be obsessed with making them look totally real—because they usually look like backdrops—but instead, use them to add a mood, an atmosphere, even an element of fantasy to your pictures. Also, you don't have to use all of a backdrop. With many large backdrops, we often photograph only a small portion.

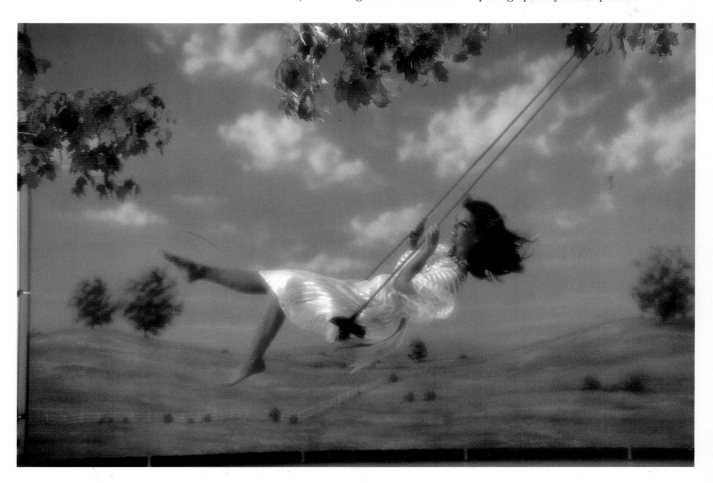

T his "grainy" look is something I love, a technique I'd like to use all the time. However, even though art directors often specifically ask to see my "grainy" portfolio pictures, I've only applied it to about five jobs over a number of years. It is a technique that falls more into the "art" end, rather than the "commercial" end, of photography.

I think enhanced grain gives a picture a very dreamy, moody feeling. But that feeling is only right for a certain kind of picture and a certain type of product. You have to know when it is right before deciding to use it. As I've said many times in this book, you only should use a technique (particularly one this drastic) when it really adds to the picture you are producing.

Grain just doesn't seem to work for cosmetics advertisements—in those pictures, people want to see skin and specific colors. It also probably wouldn't work for cigarette ads. But it has worked for a perfume advertisement, since what's really being sold is a "mood." It also could work for certain "romantic" kinds of liquor.

Here's my technique, my way of producing a "grainy" look: We use Ektachrome 400 Film, but set the meter as if we were using ASA 25 film. We take all the pictures at the same exposure, and do not bracket, or change anything.

We shoot the Ektachrome through a filter pack—a group of four gelatin filters mounted in front of the lens in a square filter holder. These four filters are: 1) a No. 1.00 neutral density filter; 2) an .80 neutral density (ND) filter; 3) an 0.025 magenta filter; and 4) a No. 10 blue filter. We always use a Nikon No. 1 soft filter, as well. It softens the enhanced grain, takes some edge off it, and keeps it from looking too sharp and hard.

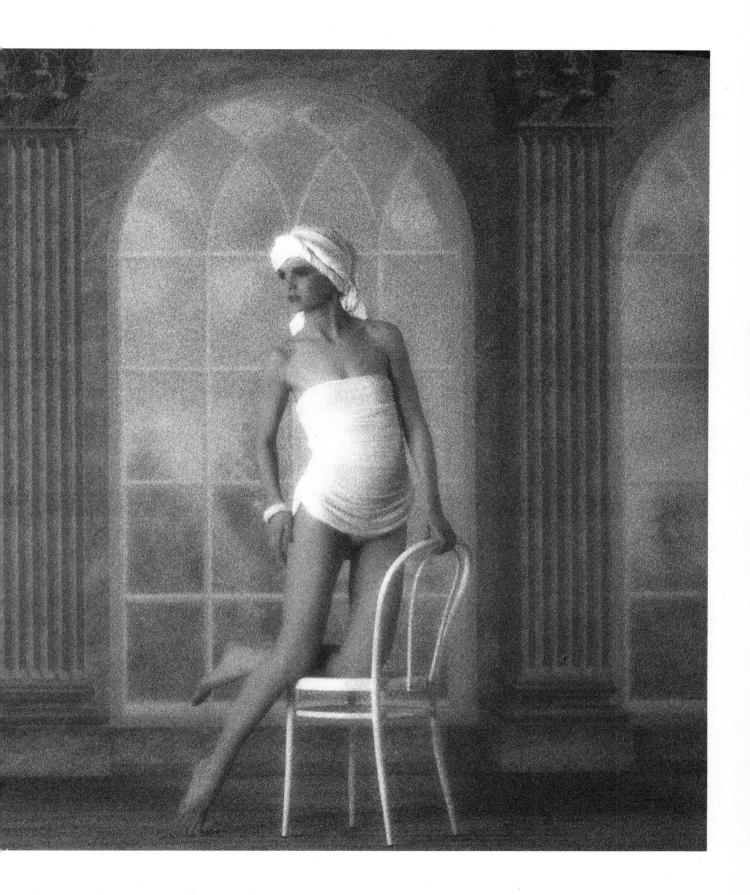

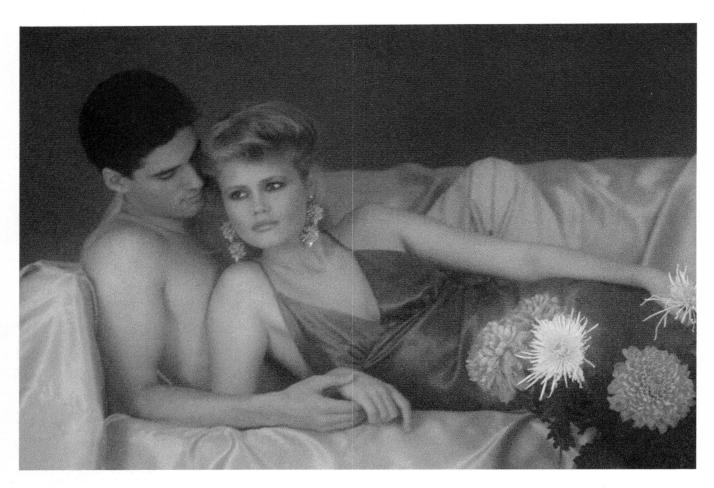

We get a lot of questions about this technique when I teach and lecture. Here is my explanation. Without using a neutral density filter, the film would be overexposed by four stops, hence the use of a 1.00 and an .80 ND filter. "Ahh," The student says, "but doesn't that equal six stops instead of four?" Yes, but in order to build up grain in Ektachrome film, one must "push" the film at least one stop in processing. In order to allow this, our ND filters cause the film to be underexposed by two stops; therefore, we can then push the film at least two stops to bring us back to the proper exposure and achieve the grain effect. Using the two color-correction filters ensures that proper color balance is maintained throughout the push processing.

After the shooting, we take one roll to the people in our lab, and have them do a four-frame clip test with the frames pushed (specially developed) two stops to give the effect of a higher ASA. Then we examine the results of the test very carefully, and determine what to do next.

If the clip test looks good, we have the whole batch push-processed two stops. If the results don't look right, we have another clip test done with the frames pushed to give the proper density. We've gone as far as five stops, and as few as two.

The amount that the film needs to be pushed depends on the subject—on whether it is predominantly light or dark. We judge results of the clip test by looking at the highlights. We keep pushing the film until they are clean, almost pure white. Whites look terrible when they are dingy. At the same time, we have to be careful not to push the film too much, and burn the highlights out entirely. You don't want to lose all the detail, but do want the whites to be clean.

There are a number of other ways to get a similar grainy effect in your photographs. People tell me about them all the time. They say that what I'm doing is too complicated, and just to use 3M film pushed one stop, or whatever. But, this technique is foolproof—as least as far as I am concerned—so I stick to it. I've used it hundreds of times, and I know how the pictures will look when I use it. That's extremely important to me. If a client wants this grainy look, I can guarantee the results. Consistency is what it's all about in commercial photography.

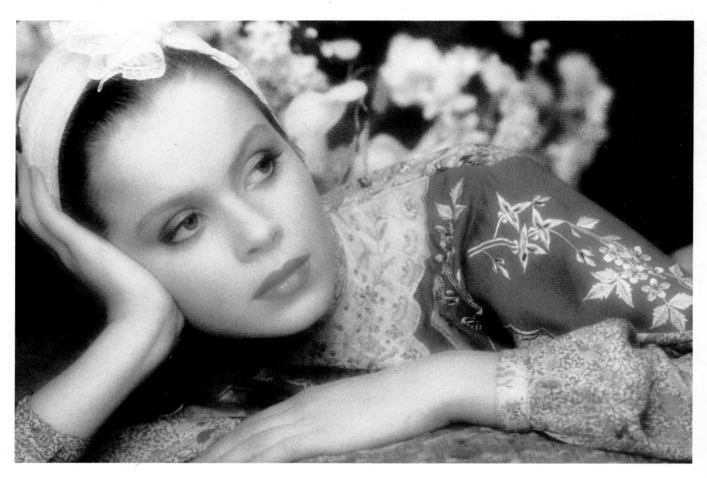

METERING, EXPOSING, AND BRACKETING

Whenever we do a shooting outdoors, we constantly monitor the situation with a hand-held exposure meter to measure light falling on the subject. An assistant stands in similar light and, anytime the light changes, he calls out the new reading.

We never use the reflected exposure meters built into my cameras, because I don't trust them, and it's not how I work. (If I were a photojournalist, or some other kind of photographer who has to work fast without assistants, I might use them.) The exposure meters commonly built into cameras easily can be fooled, especially under backlit conditions—and a lot of my pictures are backlit. We have tried out certain kinds of hand-held spot meters, and the pictures have been perfect, but I just feel more comfortable with my old exposure meter. I've used it for years, and it's never failed me.

In the studio, we begin by using an incident strobe meter, obviously. But as I said earlier in this chapter, we don't use the meter to determine the final aperture opening.

Then we take a Polaroid shot to test the lighting. If the Polaroid test looks properly exposed, we go ahead and shoot 35mm film. If it doesn't look properly exposed, we adjust the f-stop aperture on the lens or the intensity of the lights, and shoot another Polaroid. We do this (sometimes over and over) until we get a properly exposed Polaroid shot. When we get a well-exposed Polaroid shot, we adjust to the proper exposure for the reversal 35mm film we are using, and go ahead with the shooting.

We always base our exposure on the Polaroid tests, not on what the meter says, and people have asked why. Through experience, I've noticed that meters can be fooled by certain kinds of lighting, but Polaroids cannot. As a result of doing it this way, I've never blown a studio shooting because of poor exposure. (On location, under available light, I go by my meter.)

I almost always bracket (except for shots with the grainy technique or E-6 process film in general, where film is adjusted during processing to the proper density). In controlled lighting situations, I only bracket in half-stops—one half-stop above, and one below, the "proper" exposure. If you have to bracket more than a half-stop, you shouldn't call yourself a photographer, or find another system for determining exposures. You're also wasting a lot of money in film.

We get 36 pictures out of a roll of 36. All the pictures—within the brackets—are usable, as these three pictures illustrate. It's simply a matter of choice, whether the art director wants something a little lighter or darker.

There's no reason to go overboard with bracketing, no reason to waste the money.

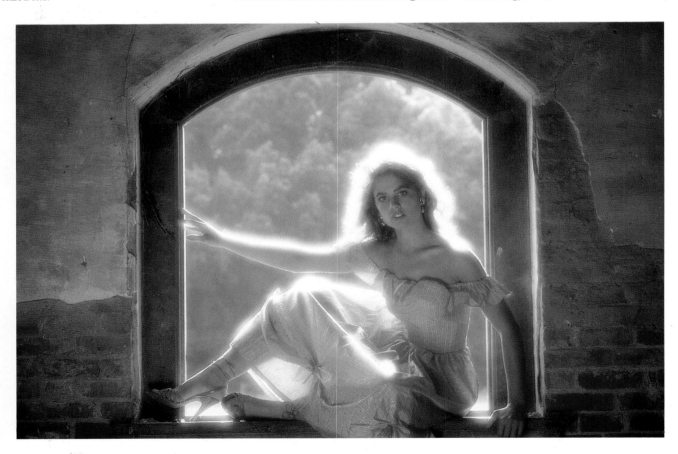

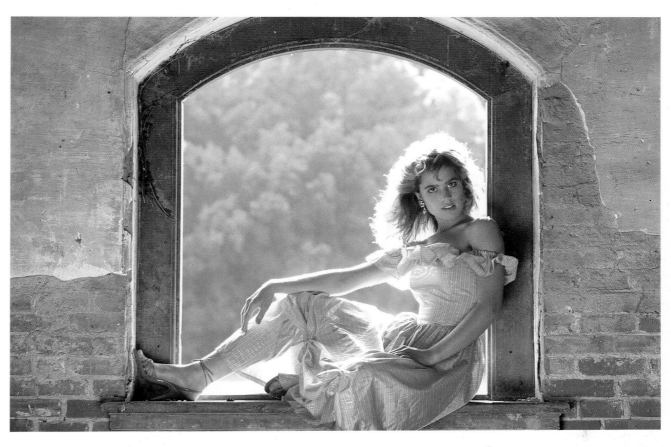

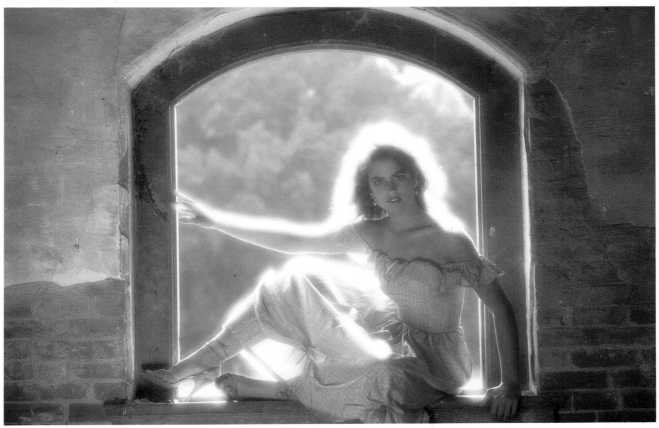

There is only one filter I use with any degree of regularity—a Nikon No. 1 soft filter. I love what it does to photographs—the way it softens the whole picture and adds a dreamlike quality. It also does great things to skin, as you can see in two of the accompanying photographs. (I hardly ever use a soft filter on men, but there is so much skin in this picture that here it works.)

There are a lot of ways in which you can diffuse pictures, and many types of diffusion filters—but the No. 1 soft filter is my favorite. It softens the overall picture without making it too fuzzy. Edges will stay sharp and in beauty photographs, eyelashes remain crisp-looking.

When I first started out, I tried the famous technique of lightly smearing Vaseline around the edges of a skylight filter and leaving the center clear. It worked, but was messy. Even worse, it was inconsistent. If the vaseline got on the wrong part of the filter, or an important subject was near the edges of the frame, it could destroy the picture. Consistency is very important to me, so when I found the No. 1 soft filter, I stuck with it. I always know what pictures I'll get.

There's a lot of difference between soft

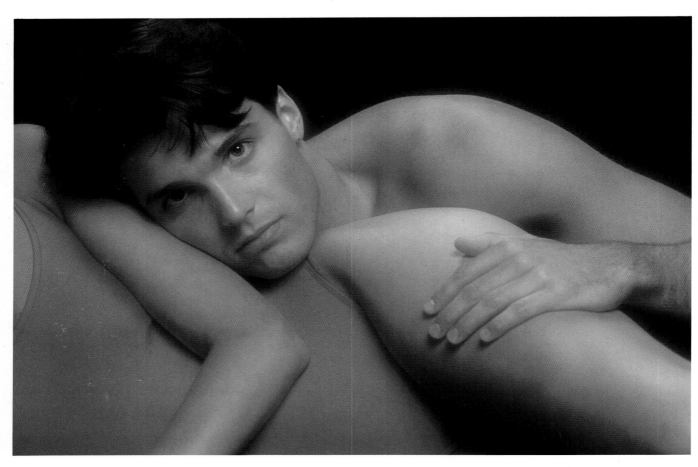

filters, diffusion filters, fog filters, mist filters, and the like. They all provide different degrees of diffusion and different looks. Some cut down light, which means you have to compensate when setting your exposure. Some, like mist filters, change the color cast of your pictures. (Mist filters turn it slightly blue, and cheap filters can do anything, so beware of them.) I've tried them all, and occasionally will use a No. 2 soft filter when I want a really strong effect.

All diffusion filters affect the light tones of the picture more than the dark areas. They do practically nothing in the shadows, and cause those flaring highlights in many of my photographs—especially when the photograph is backlit, or the highlights immediately adjoin a dark area. You really can see that flaring in the diffused picture of the couple in the white boat shown here (and in the picture of the young girl with the duck in Chapter 3).

One final comment: There's a gigantic difference between a diffused photograph and an out-of-focus photograph. In a picture that is out of focus, everything is fuzzy—dark areas as well as highlights. With diffusion photographs, the picture is still sharp, but the highlights flare (refract actually) when they strike the filter.

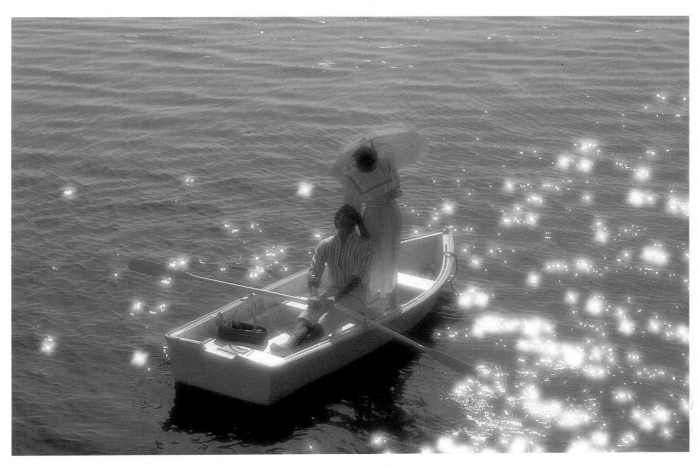

When Maidenform whispers
Sweet Nothings,
I get the message.
The silky touch of satin.
The sheer beauty of delicate lace.
The shimmering colors that
express the romance I feel.
Today it's Sweet Nothings.
And no matter how I feel tomorrow,
Maidenform will match my mood.

The Maidenform Woman.
Today she's sensuous.

Chapter 9

HANDLING PROFESSIONAL ASSIGNMENTS

A professional advertising photographer is just that—a professional. He or she is someone clients can count on to produce the pictures they need—on schedule, within budget, and without aggravation.

In many ways, a professional advertising photographer is like an actor, whose career is related to the last performance. You should have a 100 percent success rate, and give clients exactly what they ask for, nothing less. If you cannot, or do not want to, you should not take the assignment.

Executing a professional assignment is very different from taking a personal picture. Once you accept an assignment, you do what the client wants, and not necessarily what you would do on your own. You are in charge of the photography, but you work for someone else. You have the ultimate responsibility for the pictures but, at the same time, you must temper your ego and opinions for the client's requirements. It is a fine line, but you must learn to walk it.

A great deal of money depends on most professional advertising assignments. Production costs and expenses can be enormous. Besides your fee, the client pays for stylists and makeup artists. Fees for models easily can exceed a couple of thousand dollars per day. The client's advertising agency may have spent a great deal of money in marketing research, and hours of expensive creative time, before hiring you to take pictures. The ad agency may have expended a great deal of effort in presenting the advertising idea to the client and selling him or her on a specific type of picture. Media space for advertisements incorporating your photographs already may have been reserved and scheduled, at a nonrefundable cost of hundreds of thousands of dollars.

Unlike samples, tests, and personal pictures, assignments do not provide time to experiment, but are the time to play it safe. If you are not absolutely comfortable with a particular technique, don't use it. Don't do anything you're unsure of, until you have the pictures the client requested. Whenever you, or the client, are slightly in doubt, cover the situation in every possible way. Take pictures from different angles, with different clothing and lighting. After the preparation work, do everything possible to be sure you produce pictures that the client requested. After you have covered the specified assignment, only then can you safely experiment.

Professional assignments often require more logistical and preparation work than actual shooting time. Locations must be found, models cast, stylists coordinated, hair and makeup artists supervised, and so on. Lighting the scene and actually capturing the pictures are the final steps of a larger process.

One final piece of personal advice: Have fun and enjoy yourself. Help others involved to enjoy the day, too. There can be a great deal of pressure during an assignment, but if you don't enjoy what you are doing, then you are in the wrong business.

n many ways, this is what I consider an ideal assignment—a good client, a great art director, six of the world's cutest kids, and two lovely days in the country. To be honest, however, no professional photography job is completely a bowl of cherries. This assignment took a lot of hard work. Some 20 different people were involved, and the shooting had its share of anxieties before we could call it a wrap.

As I mentioned earlier, this assignment to photograph a series of ads for Strawberry Shortcake was given to me as a direct result of a sample I had shot on my own— the picture of kids with kites on a foggy beach. The art director, Larry Pillot, saw that sample, felt it had the right mood for what he wanted, and called me about the Strawberry Shortcake campaign.

These photographs were taken in Bucks County, Pennsylvania, the same idea I used for my first sample pictures of friends and neighbors. The girl is looking through a window of our old farmhouse, although we don't own it anymore. We asked the new owners and were able to pay a location fee, so they gladly let us shoot there.

The actual photography took two full days, but as is common, a lot of work was involved in getting ready. We screened 78 kids during casting, which took two full days. We photographed them all with a Polaroid camera, and sent prints to the art director so he could choose six models. We suggested the kids we thought would work best, but the final decision was up to him and the client. We hired a location scout in Pennsylvania to search out and photograph the exact spots we would use.

The stylist, Joyce Feirstein, spent days looking for the proper clothes, which she couldn't just buy in a department store since they had to look used. Joyce rummaged through second-hand shops looking for the appropriate styles, in the right sizes, with the proper amount of wear, and she finally found them.

The dolls had to look used, and that's a funny story. The dolls that the client sent were too spotless. They looked brand-spanking-new. We tried everything to scuff them up, but they were made to withstand a lot. Finally, Kaz, one of my assistants, tied two dolls to the bottom of his feet and walked on them around the studio. That worked.

The art director provided sketches of the pictures, and came on the shooting, but we still covered each situation possible. We actually wanted five pictures, but things fell into place so perfectly, we took many more. We shot numerous variations of clothes and angles. We shot every photograph sharp and with diffusion, since the client wasn't certain which type of picture would look best. The client finally chose the diffused pictures, and I'm glad.

The crew, the art director, and I stayed overnight at a local inn. The first day, one of my assistants brought down three kids and their parents, drove them all back to New York that night. The next day, he brought down three more kids with parents.

We shot many more pictures than you see here. The final edit produced 87 good images. This was great, because the client then decided to do posters, calendars, and all sorts of things. What started as an assignment for five trade ads turned into a lot more, with additional money for each usage.

The whole idea behind these pictures was that the kids were not supposed to look happy. They were meant to look as if they had just lost their best friend, but still had their Strawberry Shortcake doll. The kids were great, and knew just what to do. I don't think one of them ever smiled on camera, but they all had a great time when not working, which was perfect.

Two sketches by the art director, showing his first layouts for the Strawberry Shortcake ads.

One of the final ads, and a shot of us photographing the girl in the window. That's my assistant, Bob, about to simulate rain with a hose. As you can see, it was a hot day in the middle of July. Thank God, it wasn't too sunny!

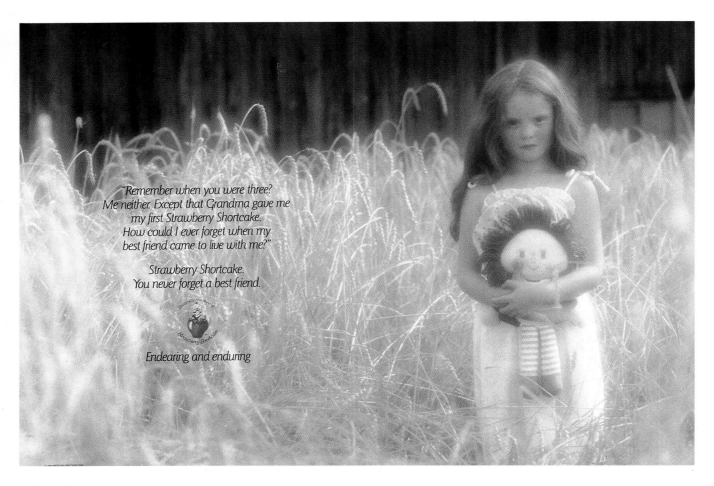

"Remember when you were three?
Me neither. Except that Grandma gave me
my first Strawberry Shortcake.
How could I ever forget when my
best friend came to live with me?"

Strawberry Shortcake.
You never forget a best friend.

Endearing and enduring

A shot of us photographing the girl in the straw field. The umbrella is used to provide a little shade, and keep the camera and film from getting too hot. That's David on the left with his shirt off and an exposure meter in his hand, taking light readings from a position similar to the model's.

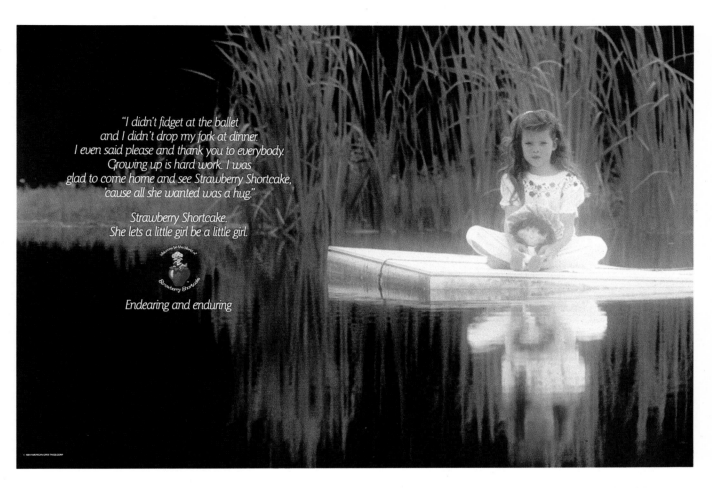

This is my favorite photograph chosen for the ads. The little girl was scared sitting on the dock, so Bob remained next to her to keep her calm, and be close if anything happened. As you can see, we took the picture from the other side of the pond with a 300mm lens. Over in the group of people, two of the other kids are playing.

his was a studio assignment. It was a set with the model, background, and product photographed—rather than all stripped—together. For ads like this, the product often is photographed separately, and the two pictures combined by stripping during printing.

To get everything into one shot, we built an unusually long set that filled much of the studio. The table with the bottle was six feet in front of the model. The model was eight feet in front of the French doors, and the painted backdrop was eight feet behind the doors. I was five feet in front of the table, shooting with a 105mm lens.

This set could be considered three sets. The table was lit with its own light, a large banklight directly over it. The painted background was illuminated by four strobe heads bouncing out of umbrellas, one positioned outside each corner of the backdrop.

The rest of the set was lit by additional strobe heads firing up into a large (15- × 15-foot) white flat suspended just above the model's head and extending over the entire back portion of the set. The light from the strobes bounced off this flat, and fell evenly and softly on the model and props.

Again, a great deal of time was spent preparing for the shooting. This is called "preproduction" work. We screened many models in order to pick (cast) the girl used, and took pictures of all likely ones for the client. We designed the set, and found the right props. As we built the set, painting it in colors similar to those on the perfume bottle, we took pictures to show the client what we had in mind.

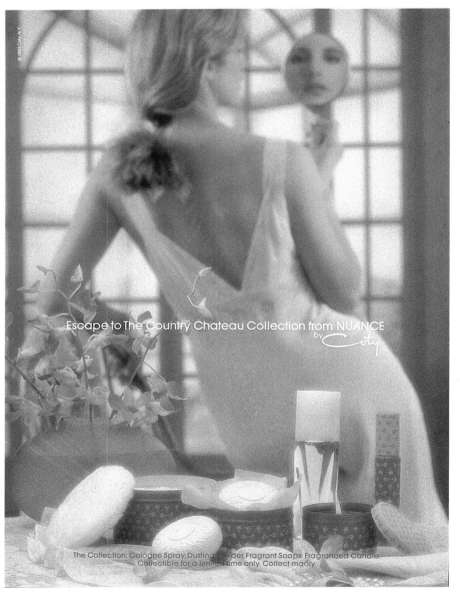

Escape to The Country Chateau Collection from NUANCE by Coty

The Collection: Cologne Spray, Dusting Powder, Fragrant Soaps, Fragranced Candle. Collectible for a limited time only. Collect madly.

Once the model and set were approved, the actual shooting took most of a day. Once again, to make sure we had exactly what the client needed, we covered the situation by shooting numerous variations. We kept to the same basic angle, but changed the clothes. We changed the flowers and props, the model's hair and makeup. We shot her facing the camera, or facing away. We played with the mirror, and what it reflected.

Whenever possible, you should cover a shooting as completely as you can. Don't just photograph a model wearing one dress, or use one lens, because you don't know what will happen. Layouts often change, and sometimes a better picture idea suddenly crops up when you are shooting. After all the preproduction work, it makes sense to take advantage of the situation, rather than go through it all again later if somebody changes his or her mind.

This was a two-part campaign, with one ad published during the summer and another designed to run in the winter months, so we later took another photograph. This time, the picture was to have two models—a couple—the same exact mirror shown on the perfume package. This mirror could not be borrowed or rented, so we had it built by a professional model maker. That cost about $2000, but the client had to have it.

Again, we covered the situation by shooting numerous variations on the same basic photograph. My favorite is the picture with the model wearing a satin teddy. But the client chose another variation for the ad, so I guess the teddy was too sexy for the headline.

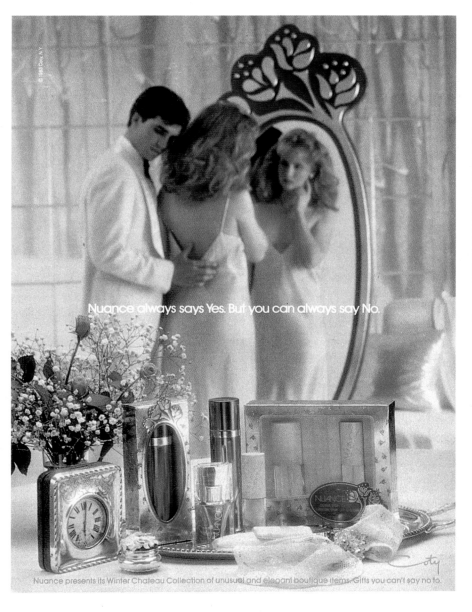

Nuance always says Yes. But you can always say No.

Nuance presents its Winter Chateau Collection of unusual and elegant boutique items. Gifts you can't say no to.

This is a series of advertisements for a brand of Canadian cigarettes, which was photographed on location in Barbados. Seventeen of us—including a production crew of eight, six models, and a lot of luggage—went down there for a week. We photographed the entire campaign, a number of different ads, in one single trip.

This assignment again was the direct result of a sample photograph. We published the picture in a Canadian creative directory, and used overprints of that page for a mailer. This picture—two girls frolicking in the breaking surf—caught the attention of the art director for the Belvedere account at Leo Burnett. It included the exact subject that he wanted, along with the happy, healthy feeling.

This sample, taken one lovely, lazy afternoon on Fire Island, caused the art director to call and ask to see my portfolio. The portfolio we sent convinced him that I was the right person for the job, that he could be secure in assigning me and authorizing all expenses involved in sending a complete crew to Barbados.

This is a real commercial job, the kind of high-budget assignment that doesn't come along every day. It also was a lot of fun. All week long, we took photographs of couples and groups enjoying themselves in the sunshine on the beach. We rented brightly colored props like the jeep, and used comfortable, casual clothing for the wardrobe.

The weather was gorgeous, so good that we had to simulate rain for the shot of four people laughing under a yellow slicker. One of my assistants, Bob, and one of the client's people did that easily enough with two garden hoses. The models' great expressions may have been due to how absurd and funny it was to be faking rain on a beautiful day. The slicker cast a shadow and added a yellow tinge, so we used a good deal of fill light in this picture. Two assistants were standing just outside the frame with large white cards, and bouncing the sunlight back onto the models from low in the front.

The pictures the client used were taken outdoors with available light and a few reflector cards. But we also brought along cases of lighting equipment, just in case. We

also brought all sorts of clothes, a number of small props like sunglasses and binoculars, and needless to say, the client shipped us cartons of their cigarettes. I don't smoke, and neither did most of the models and crew, so we ended up giving the unused cartons to hotel workers.

We also brought our own film, and took it back to New York for processing. This was a long shooting, so we took along at least six bricks (20-roll packs) of Kodachrome. I always bring my own film whenever I go on location, especially outside the country. We test the film before leaving, so we know if that particular emulsion batch has a color cast, and what filtration to use to correct it. Also, I always bring more film that I'll need.

I'm sure they sell Kodachrome in Barbados, but I wouldn't buy any. You don't know how long it's been sitting on a dock or shelf. I wouldn't want to get back to New York and discover that the last 20 rolls I shot were all too green, or too red. I especially wouldn't want to tell the client to send us all back to Barbados because I hadn't brought enough film and had picked up a few rolls there to fill in.

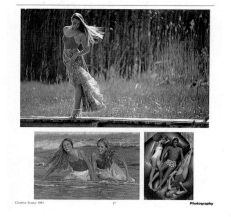

Leo Burnett (Canada) in Barbados for Belvedere Cigarettes

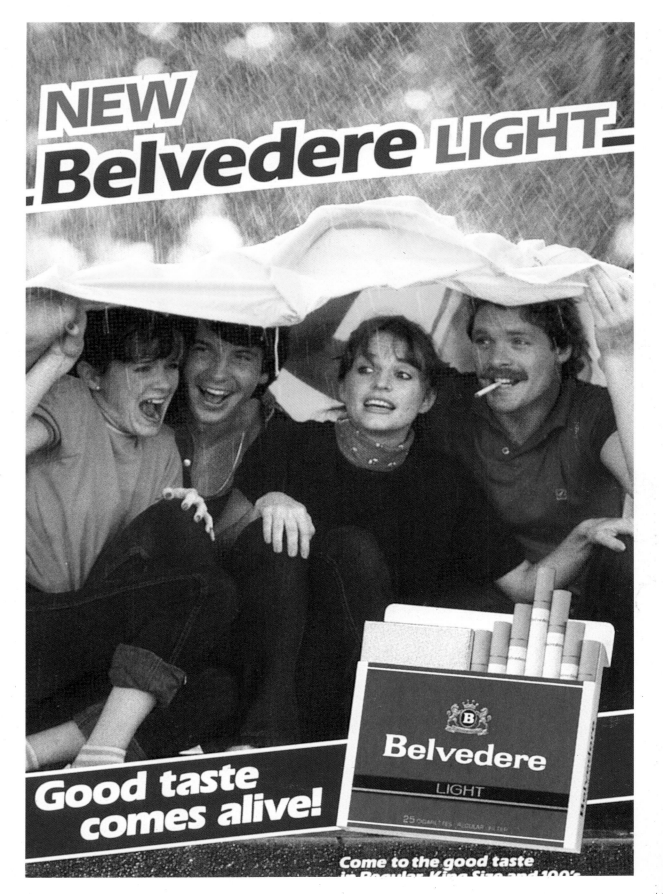

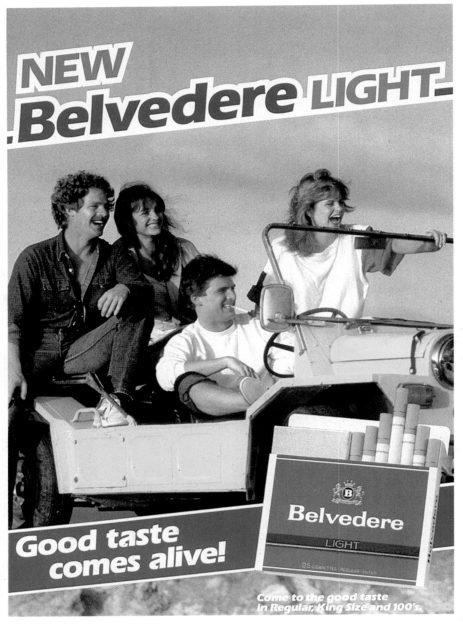

On the same subject, when you go on location with models and a crew, especially a foreign location, remember that your exposed film is the most valuable thing. In a lot of ways, it is more expensive and important than your camera equipment or passport. Those can be replaced more easily and exactly than exposed film can be re-shot.

Watch and guard your exposed film, especially on location. It's not worth much to anybody else, but it could be a problem if it were stolen or damaged. On this Belvedere shooting, we guarded the exposed film like hawks. We hand-carried it on and off the plane, although we checked a couple of thousand dollars' worth of equipment. We didn't store the film in the overhead racks, but had an assistant sit with his feet on it. We didn't allow it to be X-rayed at any airport, and were willing to miss flights and waste time, if necessary, to keep it from being X-rayed.

By the same token, when we got back to New York, we didn't send out all the film for processing in the same batch, but in two different batches. That way, if there were some failure in processing, or somebody misplaced a package, we wouldn't lose the whole shoot.

If something unfortunate happens to your exposed film after a big shooting, it's your fault, and you're up the creek without a paddle. If everyone else has done their job properly, they should be paid. You alone have not delivered the chromes the client wanted. This could harm not only your relationship with that client, but possibly your entire career. Expenses for a commercial shooting can be high, and paying twice to do a shooting is hard on clients.

A failed shooting also could escalate into more than simply paying photography costs. Not having the pictures on time could destroy media schedules involving a client's commitment of tens, even hundreds, of thousands of dollars. People who hired you might be fired, and the advertising agency could lose an account.

Advertising photography is a business, not a hobby. You must realize the value and importance of your pictures, and guard exposed film at any cost. It's your career at stake. Knowing that, you must take every precaution.

NEW
Belvedere LIGHT

Good taste
comes alive!

Belvedere
LIGHT
25 CIGARETTES REGULAR FILTER

Regular,
King Size and 100's.

DRESS FOR SUCCESS.

To be a success in business, it's important to look the part. But it's what you know that really counts. And that's why you need Business Week. Week after week, Business Week keeps you informed on what's happening in business. And how it may affect your business. So you can be prepared for any situation.

And take advantage of any opportunity. If you're looking for a way to groom yourself for success, there's a fitting solution. A subscription to Business Week. Send in the attached order card or **call toll free 1-800-635-1200.**

BusinessWeek
THE VOICE OF AUTHORITY

T his picture looks like a shot of three girls off the street, but it isn't. Finding the right models took a lot of work and casting. Finding the right clothes also wasn't easy. The client was very specific and picky. We must have procured and looked at more than 20 different dresses and suits, before receiving approval from everyone involved.

The client was adamant that the models must look "real." It's a request we get often, and real-looking models are often very difficult to find. There are modeling agencies that specialize in real-looking people, but the majority of professional models look like professional models. Something about their pictures always conveys that they are not shots of a real businessman, or a real businesswoman, or a real "boy next door."

The pictures were taken in the studio and, technically, they were quite simple. The background was a roll of standard dark gray seamless paper. The lighting was one single banklight in front and slightly to the left of the models. Two flats on the right provided some fill light. The lens was a 105mm, and the film was Kodachrome 25. The largest amount of work was done casting the models, finding the proper clothing, and styling the girls to look good, but not too good.

As you can see from the tearsheet, the final picture was just slapped across the top of the advertisement, and reproduced in black and white. It's not a very exciting design or picture, but when you make a living as a photographer, it's the kind of job you sometimes have to take.

In building a career as a photographer, you must learn when to bite your tongue, ignore your ego, and do what the client wants, even when you hate it. You learn to look forward to the more exciting, interesting assignments, and realize that certain jobs just pay the rent. Without paying the rent, you won't be able to stay in business long enough to get the good assignments.

This was another job that just paid the rent, but I think it's cute. It was crazy, but a lot of fun.

This was a casting nightmare. The client wanted three young black babies, who had to be old enough to sit up, but not crawl. One was to be dressed in baby blue, one in pink, and one in pastel yellow.

We cast for two days to find the right babies. There must have been 20 babies in the studio at one point. When we put a baby on the seamless for the polaroid shot, the baby would just sit there (in shock, I think, because everyone was looking at it), which was just what the client wanted. All the mothers were asked if their babies could crawl, and most replied no, they hadn't learned how to yet.

After the casting, the client chose six noncrawling babies—but on the day of the shoot, five of the six had learned to crawl! The mothers acted as if this were the first time they had ever seen them crawling.

We spent an entire day shooting. We would put the babies down on the seamless paper, and two of them would scurry all over the place like ants. They'd be off the seamless paper faster than we could bracket. We had assistants and mothers positioned along all the edges. We'd put the babies down and shoot quickly while they were still in the frame. Then we'd have to put them back and shoot again, all day long. It was one of those situations in which you just shoot and shoot, and hope you catch it.

It was quite crazy, but a good day. None of the babies cried, and no one had a bad time. Once in a while, we'd take a break to change a diaper, and everyone would laugh and joke.

With all of this happening, we kept the lighting quite simple—one big banklight on a boom slightly in front and above the babies, and a few white flats around the sides of the set reflecting back some fill light. Enough was going on without worrying about an elaborate lighting arrangement.

This was a book cover that we photographed for the Putnam's Publishing Company. The title of the novel was *Her Father's Daughter*. It wasn't literally an "advertising" assignment, but required many of the same approaches and techniques used for advertising photography.

I've photographed a number of book covers for Putnam's. This time, the assignment called for a picture of a sexy woman in an environment that symbolized wealth and power, so we decided on a model getting out of a limousine. The client's one request was that the model have great legs, like the character in the book.

We cast a number of girls, in order to find the right model—one with great legs and the right "banker's daughter" look. Once we found the model, we rented the limousine from a car service company.

The pictures were taken on the street in front of my studio. We had to get an official location permit from the city in order to block the sidewalk and park in front of the fire hydrant. Joyce Feirstein was the stylist, and Deborah Steele did hair and makeup.

The pictures were shot late on a cloudy winter's day, with a combination of strobe and tungsten lighting. The film was Kodachrome 25. One strobe head bounced out of an umbrella behind my shoulder and was

the main light. Inside the limo, we placed a secondary tungsten spotlight. This light illuminated the backseat, provided some detail, and added the orange color. Mixing strobe and tungsten light is a technique I love to use. A small area of tungsten light adds a little warmth and a great deal of interest to almost any picture.

As usual, we covered the shooting a number of ways. We dressed the model in two different outfits so the client and art director could have a choice. Joyce and I preferred the shot of the model in a shiny blue-green jacket, but the client chose a picture of her in the gray jacket. I guess the gray jacket looked more like "old money."

The Maidenform lingerie campaign didn't come to us because of a single sample or mailer, but rather as a result of many promotional pieces sent over a period of years. Dick Voehl, who was the art director on the Maidenform account, had received each one, become familiar with my name, and watched our work for a number of years. When Maidenform decided to change the style and thrust of its advertising, he contacted us about the new campaign.

The previous Maidenform advertisements featured a woman wearing only underwear in unusual situations. The copy line was read: "You never know where she'll turn up." That campaign was shot by a number of male photographers. The ac-count changed agencies, and for the new campaign, the client decided on a more glamorous look, combined with elegant settings. That's one type of work I do best, and the client loved the idea of having the photographs shot by a woman, so I was awarded the campaign photography.

We've worked on Maidenform ads for three years now. The first year, the ads were all on single pages and combined three separate images. The second year, the ads were two-page spreads, with a number of smaller pictures inset in a larger, elegant, background picture. This year, the ads feature a single picture. The ads usually are run as a series, with two or three different ones on consecutive pages of the magazine. Every year, the idea is changed slightly.

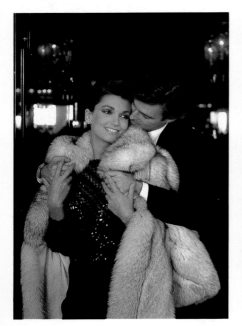

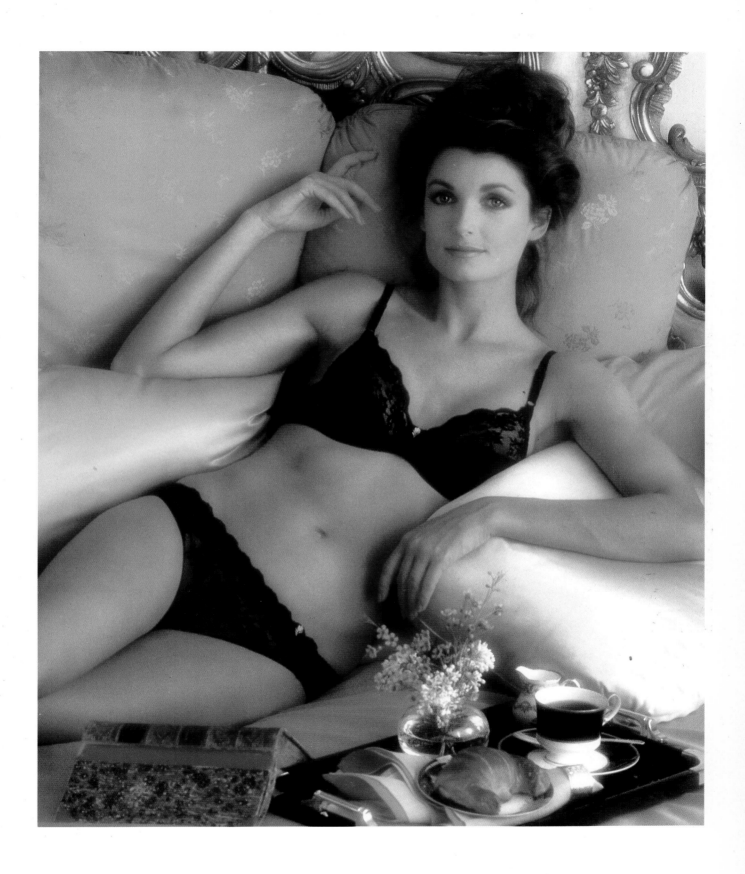

This type of photography is very complicated, not to shoot, but to produce. Each session take days of casting, a good deal of location scouting, with a lot of styling and time spent finding props. My assistants love the casting when it begins—all these beautiful girls running around the studio in their underwear—but it is hard work, and by the end of the day, they probably can't stand to see another girl in panties.

The models used in this type of advertising usually make more than the photographer. They get a high daily rate, and a bonus because the product is lingerie. After six months, the models get another bonus if the client keeps running the ad. With this bonus, the model can make more in one day's work than the entire crew of photograph, assistants, stylists, and hair and makeup artists put together.

These types of glamorous locations are also very expensive. Typically, a mansion used on the location for a major consumer advertisement will cost $1500 or more for a single day's shooting.

Props also can be very expensive. The kitten in one picture cost $300 to rent for one day.

The trunk behind the girl with the telescope in this picture cost $1000 to rent for a single day. The photograph required that type of trunk, and time was so tight, we only could find the trunk on a soap opera in New York. We picked it up in the morning—it wasn't being used that day—and brought it back in the afternoon. With enough notice, we could have rented a similar steamer trunk from a prop company in Los Angeles, and shipped it by air to and from New York for much less.

Of course, we called the art director before spending $1000 to rent the trunk. We suggested other props that might be used for the same picture, but the client wanted that exact type of trunk—an old-fashioned steamer trunk. Any time an expense seems to be way out of line, or there's any major change, you should call the art director to clear the change or cost before proceeding. In this case, the art director verbally authorized the expense.

We used a similar type of lighting for almost all the Maidenform photographs—a number of strobe heads diffused through a huge piece of white parachute material stretched between two extended poles wedged between ceiling and floor. It is a very soft lighting, similar to that produced by a huge banklight. It is also a very transportable setup, which comes in handy since the Maidenform ads are shot on location, which frequently changes at the last minute. When necessary, we also bounce strobes off the ceiling or large sheets of foamcore for additional fill light, and occasionally add umbrellas or bright reflectors to highlight particular areas.

This is a wonderful campaign, and lots of fun. The art director is very talented, and a pleasure to work with. He sets up the basic idea, and then we work with the situation and the models to produce the best pictures. Nothing is "written in stone," and there are no tight sketches that must be followed to the letter. At the end of the day, we are exhausted, but we've had a good time and the pictures are great. It is work I can be proud of, the kind I enjoy most.

*When I want to create magic,
I slip into Chantilly.™
The enchantment of delicate lace.
The spell of silky satin.
In a very tempting assortment of colors.
Today it's Chantilly…
Maidenform's irresistible
intimate apparel collection.
And no matter how I feel tomorrow,
Maidenform® will match my mood.*

The Maidenform Woman.
Today she's alluring.

GLOSSARY

The following definitions of certain specialized or slang terms are used in the business of professional photography and in this book. They may be unfamiliar to some readers.

Account: One specific company (or division of a company) for which an advertising agency does work on a consistent basis. Nikon, Inc. is an account of the agency Scali McCabe Sloves. Purdue Chicken is another account. Normally, an agency has a specific group of people assigned to each account.

APA: The Advertising Photographers of America. A national business organization of commercial photographers.

Art Buyer: A person at an advertising agency responsible for the financial aspects of working with photographers, illustrators, and other independent (nonstaff) creative and production suppliers.

Art Director: A graphic artist or designer responsible for the visual appearance of an advertisement or other printed communication. Usually this person is the professional photographer's primary contact.

Assistant: A person (often a beginning photographer) who works for an established professional photographer, either on a staff or freelance basis, and helps in the production of photographs.

Bank: A large, artificial light source that produces a soft (diffused) illumination. Normally rectangular or square in shape, it often combines a number of separate, point-light sources, such as a group of multiple strobe heads. It is used for many types of photography, and commonly for still-life photography, and often is referred to as a "banklight."

Beauty: A particular type of commercial photography, usually a tight photograph of a person's face produced for a cosmetics client. It differs from a portrait in that the primary subject is not the person or his or her personality, but the subject's appearance.

Bid: A firm statement of the price for which a professional photographer will produce a particular picture. It is different from an "estimate" and commonly includes the photographer's (and staff's) fees, as well as all production expenses and charges. Usually it is related to specified media usage by the client.

Bleed: A publishing format in which a photograph (or other material) extends to the edge of the page. This format requires the image to be printed larger than the page, and the paper to be trimmed after printing.

Book: A photographer's (or other artist's) portfolio of work.

Boom: A support system for lighting (or other) equipment, which is easily adjustable and includes a large, horizontal arm.

Bracket: A slight variation above or below a particular exposure. It is a technique used by photographers to ensure proper exposure.

Brick: A unit of 20 rolls of 35mm film. It is usually shrinkwrapped, since it comes from the manufacturer.

C-print: A specific type of color photographic print. It is different than a "type R" print, a "Cibachrome" print, a "color stat," and numerous other types of positive color prints.

Casting: The process of screening a pool of models, actors, or other talent in order to make a final selection. In commercial photography, "casting" often requires seeing numerous candidates, and taking test or reference photographs, usually Polaroids, of all possible selectees.

Chrome: A positive photographic color transparency.

Ciba: The shortened version of Cibachrome, the product name for a specific type of positive color print material manufactured by Ilford, Inc.

Client: A person or company commissioning or buying some service or product. In commercial photography, this term usually refers to the end user—the company the photograph is promoting—although that company is technically the client of the advertising agency, and the agency is technically the photographer's client.

Clip test: A technique in which the first few frames (or sheets) of photographic film are specially developed first in order to determine the proper exposure for the rest of the film, or the balance, as it is called.

Comp: A shortening of the term "comprehensive layout." It is a detailed mock-up of a graphic design showing the idea and components that will be included in the final printed piece. It is commonly used by ad agencies and graphic designers to present their ideas to clients, and often is used (after client approval) as a guide for production of the final photographs.

Copy: The words (text) used in an advertisement or other piece of printed communication.

Copyright: The law that guarantees the originator of a creative work (such as a photograph) exclusive ownership and control over that work from the moment of its creation as a tangible property. All creative works that are published must be accompanied by the proper copyright notice in order for them not to fall into "public domain" and forfeit copyright protection.

Cover: The practice of taking numerous slightly different photographs of a given situation in order to ensure variation for the client and avoid reshooting.

Creative Director: A person at an advertising agency (or company) responsible for the creative elements of an advertisement or other printed piece. Usually superior to an art director or copywriter, this person is concerned with the conceptual aspects of both visual and editorial material.

Creative directory: An advertising medium in which professional photographers (and other creative and production suppliers) buy space (and/or listings). Commonly, it is published as an annual book, and distributed free to buyers of art and production services as a resource for ideas and contacts.

Drop out: A printing term describing the process by which specific areas of a photograph or image are not printed, thereby appearing pure white on paper. Blocks of text copy can also be said to be "dropped out" of an image area if this specific process is used in printing.

Dupe: A copy or duplicate of a positive transparency.

Emulsion batch: Film is manufactured in separate runs (or batches), each of which is labeled with an "emulsion number" or code. Different batches of film have different characteristics.

Estimate: An accurate, researched calculation of the fees, expenses, and production charges that will be required for a particular photographic assignment. It differs from a "bid" in that it is a calculation of costs, not a firm statement of overall price, and a bid is usually made by a number of photographers competing for the job.

Expenses: The production charges and costs carried by the client, either directly or through reimbursement of the photographer. These are usually different, and separate, from the photographer's and other creative individuals' "fees."

Feather: The shielding of a light source so its illumination does not strike unwanted areas in a scene.

Fee: The money paid to a photographer for doing certain work. It is usually different, and separate, from "expenses," "production costs," or "production charges." Normally, it is calculated by considering the use to which the client will put the picture, the amount of time required for the work, the reputation of the photographer, and the complexity of the assignment. It is also referred to as the "creative fee."

Flat: A large, easily movable, surface. It is commonly either white or black, and rectangular, and is used for building sets, as a lighting tool, and numerous other purposes.

Foamcore: A generic type of board composed of pressed, synthetic, foamlike material bonded inside harder, smoother, outside panels. Usually it is quite light, easy to cut, and is used to bounce, block, and direct light.

Freelancer: An independent (nonstaff) contractor who works on a project basis. Freelancers are normally self-employed, and often work for numerous clients concurrently. Most stylists, makeup artists, and assistants are freelancers.

Gobo: A device used to "go between" or shield a light source, directing the light so that it only strikes one particular area of a scene. Usually made of cardboard or fabric, a gobo can also be used to prevent lens flare.

Head: There are three common uses of this term in the industry. The first (used in this book) refers to the part of strobe lighting equipment

that contains the flash tube, which is separate from the power pack. Another common use refers to the top of a tripod (or other support device) immediately connected to a camera or piece of equipment. A third use refers to the shortened word for "headline," the largest (and usually first) words in an advertisement or editorial article.

Head shot: A photographic portrait that only includes the subject's head and shoulders.

Layout: A representation (often a sketch) of a graphic design produced prior to the final printed piece. Normally, it is less exact and detailed than a "comp."

Lamination: A photograph, tearsheet, design, or other piece of artwork that is bonded inside clear plastic or acetate. It is commonly used to protect or preserve the piece, and often is used for professional photography portfolios.

Location: A setting—outside of a studio—used for professional photography, video, or film production.

Mailer: A printed promotional piece sent by a photographer to potential clients as a sample of work, with the intent of soliciting business.

Media usage: The way (and places) in which a client will publish or display a photograph. Media usage is a crucial component in determining the value of a particular commercial photograph and the creative fees to be charged. For magazine and newspaper advertisements, the media usage is commonly calculated by considering the publication's circulation, the number of times (or length of time) the advertisement will be published, and the prestige or reputation of the publications in which both the advertisement and photograph will be published.

Modeling lights: Continuous incandescent lights mounted adjacent to the strobe tubes of an electronic flash, primarily used for visualizing the effect of the light from the strobe flash. Modeling lights are usually low in power.

Pelon: A translucent, fireproof cloth used to diffuse a lighting source, such as a strobe head or strobe head with an umbrella. This can be simple parachute cloth.

Period: A general term for an illustration photograph with an "historical" appearance, such as a "period photograph." It can refer to any old-fashioned-looking picture.

Plexi: A shortening of the word "plexiglass," a particular type of plastic (acrylic-based) sheet. ("Plexiglas" is a trademarked product.)

Pole cat: The brand name for an easily adjustable and simple-to-erect vertical support system, commonly used for hanging background paper, and canvas backdrops, and for supporting flats.

Power pack: The main unit (power source) of an electronic strobe system, which contains the capacitors and controls, and is connected to separate strobe heads by power cords.

Production: The logistical operation of procuring and coordinating all the elements necessary for a photograph, and the actual photographic session once everything is set up.

Production charges: The costs, other than creative fees, required to put together a photography shooting. These include prop purchase and rental, film purchase and processing, staff time, and the like. They are similar to "expenses," but different from "creative fees."

Production manager: A studio employee (or freelancer) responsible for coordinating the elements of a shooting. This person is in charge of a shooting from beginning to end.

Pull: Specialized processing of film to effectively reduce the ISO (sensitivity) of that film. It is the opposite of "push."

Push: Specialized processing of film to effectively raise the ISO of that film. It is the opposite of "pull."

Residuals: Payments made to models, actors, and other "talent" in a photograph, which are contingent on the client's usage of their images. Typically, a model will receive payment for the actual act of modeling, and for an initial period of usage of the image by the client. If the client decides to continue using the picture for a longer period of time (or in other ways), the talent will receive "residuals" for that additional usage.

Rights: A client does not normally "buy" a photograph. He or she licenses the "rights" to specific usage of that photograph, but the photographer and creator retain actual ownership of it. Theoretically, there is an infinite number of separate rights (possible licensing arrangements) included in any creative work. Rights can be either "exclusive" or "nonexclusive," and are usually granted for specified reproduction formats, in specified market areas, and for specified length of time.

Royalties: Payments made to a creator (commonly an author or artist) by a second party (usually a publisher) after sale of reproductions of that creator's work to a third party.

Sample: A test photograph produced without a paying client. It is commonly used to show and sell a photographic approach or idea. Samples are what constitute a portfolio.

Scrim: A surface used to shield or diffuse a light source.

Seamless: A shortening of the term "seamless paper." It is a roll of paper used to cover a large area of a background or set with a single sheet that doesn't have any seams.

Separation: A printing term. Continuous-tone color photographs are "separated" into four sheets of screened film, corresponding to four colors of ink (magenta, cyan, yellow, and black), in order to be printed by the offset process. These sheets of film are collectively referred to as "separations."

Set: A fabricated environment, usually in a studio, constructed especially for photography.

Spread: A printing and graphic design format in which the same visual or editorial material is "spread" across two facing pages of a publication.

Stock: Existing photographs available for licensing or purchase by clients. "Stock photographs" are different from "assignment photographs," which are created on demand.

Stripped: A term that describes the technique of adding an element to an existing photograph or design after creation of the original image. Type is commonly "stripped" into a photograph, and pictures of products are often "stripped" into larger illustration photographs.

Strobe: A powerful electronic flash used for lighting photographs. Typically, strobes flash for a very brief duration (less than $\frac{1}{400}$th sec.). The term is usually reserved for larger equipment, which cannot be mounted on the camera.

Strobe head: The part of electronic flash equipment containing the strobe tube, and separate from (but connected to) the power source.

Studio manager: A person, normally an employee but separate from the photographer, responsible for the day-to-day operations of a commercial photography studio and business.

Stylist: A professional (often self-employed) person who concentrates on the objects (and their appearance) in a photograph. Stylists typically have good contacts for procuring clothing and props, a sense of fashion and design, and a great deal of ingenuity. There are many specialized types of stylists, from food stylists to fashion stylists.

Tearsheet: A printed sample of an advertisement or editorial piece, which is removed (torn) from the larger publication in which it was originally reproduced. It is used by photographers, models, art directors, and other professionals as an example of past published work.

Test: A photography shooting without a paying client. It is normally done to experiment with ideas, or to build material for a photographer's, model's, or allied professional's portfolio. It is similar to a "sample."

Tungsten: A type of continuous light source with a bulb and filament, and a color temperature of around 3200 degrees Kelvin. Normal household lamps are tungsten, as are much brighter quartz lamps and spotlights.

Umbrella: A collapsible photographic lighting accessory that is commonly used to effectively enlarge (or diffuse) a smaller artificial light source (such as a strobe). There are three main types of photographic umbrellas (silver-lined, white-lined, and translucent).

Usage: The way and length of time in which a client reproduces or displays a photograph. It is related to the concept of rights, and the number of people who will see that photograph. A one-time advertisement used in all editions of *Time* magazine is one example of usage. A display print hung in the reception area of a company's offices for two years is another example.